WE IMAGINE
WE DRAW
LANDSCAPES

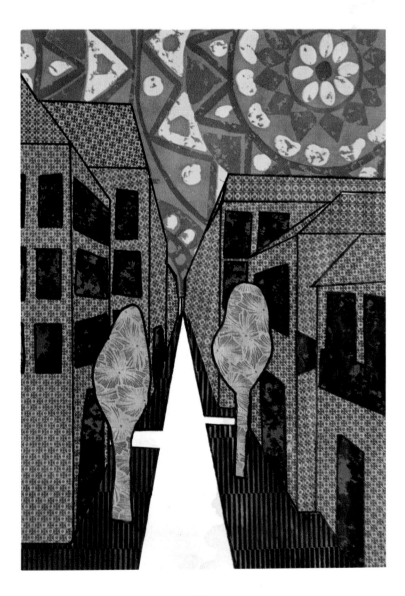

The words in *italic type* are explained in the Glossary on page 48.

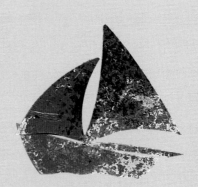

Original title of the book in Spanish: *Dibujar y Crear Paisajes*
© Copyright Parramón Ediciones, S.A.1997—World Rights
Published by Parramón Ediciones, S.A., Barcelona, Spain.
Author: Parramón's Editorial Team
Illustrators: Parramón's Editorial Team
Translated from the Spanish by Edith V. Wilson

© Copyright of the English edition 1997
by Barron's Educational Series, Inc.

All inquiries should be addressed to:
Barron's Educational Series, Inc.
250 Wireless Boulevard
Hauppauge, New York 11788

International Standard Book No.: 0-7641-5041-3

Library of Congress Catalog Card No.: 97-17667

Library of Congress Cataloging-in-Publication Data
Dibujar y crear. Paisajes. English
 We imagine, we draw. Landscapes / [author, Parramón's
Editorial Team ; illustrators, Parramón's Editorial Team].
 p. cm.
 Summary: Provides instruction on how to draw landsca-
pes.
 ISBN 0-7641-5041-3
 1. Landscape drawing—Technique—Juvenile literature.
[1. Landscape in art. 2. Drawing—Technique.]
I. Parramón Ediciones. Editorial Team. II. Title
NC790.D5313 1997 97-17667
743'.836—dc21 CIP
 AC

Printed in Spain
9 8 7 6 5 4 3 2 1

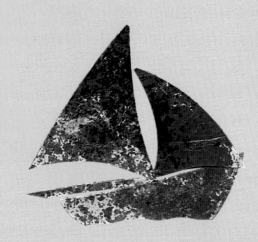

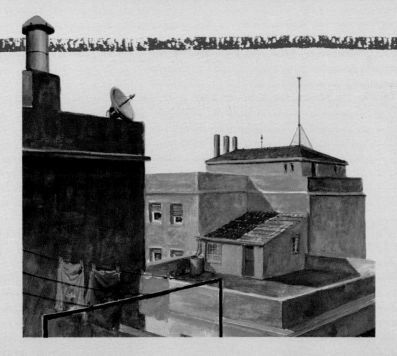

Contents

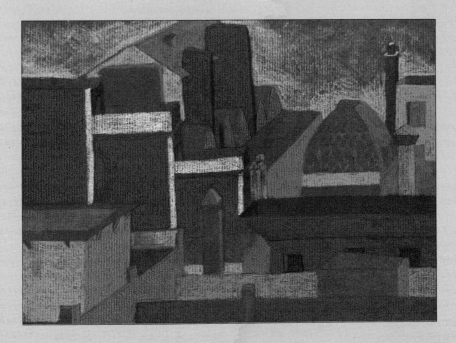

Landscape and Perspective

This brief introduction to the basic rules of *linear perspective* will help you draw more realistic pictures. Although we will discuss perspective only as it relates to landscape, the information applies also to objects, the human figure, and much more.

First, you need to understand that the world you see around you has three dimensions: height, width, and depth. You can find the proof of this fact in any solid object. For example, look closely at the dresser in your room and you will find that it has three measurements—from top to bottom, from side to side, and from front to back. These measurements correspond to the three dimensions.

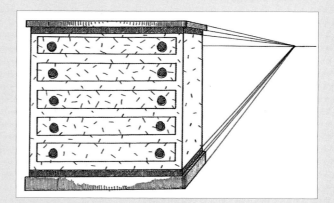

▲ **Drawing of a dresser with three measurements.** Linear perspective is a means to capture on a flat sheet of paper, which has only height and width, the three dimensions of an object as your eyes see it in three-dimensional space. To use perspective in drawing, you first need to become familiar with two of its basic concepts: the *horizon line* and the *vanishing point*. Now, imagine the following situation:
1. There is a landscape.
2. There is a sheet of paper; think of it as a window or a viewing frame.
3. There is an observer.

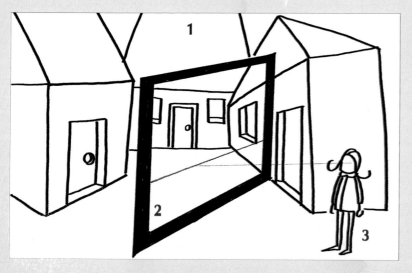

◀ **In this illustration there is a landscape, a viewing frame, and an observer—corresponding to items 1, 2, and 3 (above). The horizon line (dotted) within the frame indicates the exact height of the observer's eyes.** The horizon line is the horizontal line that you draw, or imagine, on the sheet of paper to show the level of your eyes relative to the ground. On this line, you will place all the vanishing points, which are the places where all straight lines that represent parallel lines in a drawing meet. By definition, parallel lines *never* meet. If you could stand in the middle of an old, unused railroad track, however, you would find that your eyes see things differently. You *know* that the rail lines are, indeed, parallel. Nevertheless, you *see* them coming together as they recede, or go back, into the distance.

▶ **This illustration shows railroad tracks meeting at a distant point.** Now you know that although in reality parallel lines *never* meet, your eye makes these lines appear to come together at the point where they vanish from your view. Because you must draw what you see, the vanishing points will help you to construct your drawing.

Depending on your position relative to the object you are drawing, you can have one, two, or more vanishing points in a drawing.

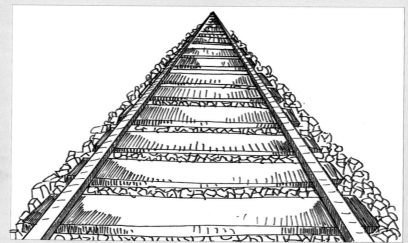

To begin, you are going to draw a street with a one-point perspective—that is, perspective with a single vanishing point. Study the parallel lines of a street that has been closed to traffic. Stand where the block begins, with the street directly in front of you.

◀ An aerial view of an observer and a street. This exercise will prove that the curbs, windows, and all other elements that in reality form parallel lines, in your view will come together at the horizon line, which is always level with your eyes.

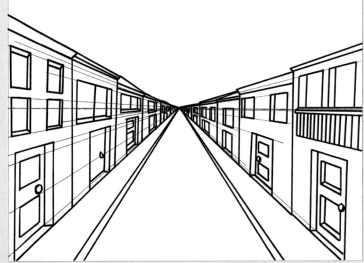

▶ A long street with vanishing buildings. Note that the receding lines of perspective make the distant windows appear less tall than they are in reality. Your eyes will always see any lines that are not parallel to you as being shorter than they are in real life. Hold your pencil in a parallel position in front of your eyes. This angle lets you see its actual length. Now, tilt the pencil slightly and turn its point a little away from you. Do you see how the new angle of view *foreshortens* the visual image of the pencil and makes it appear smaller than it actually is?

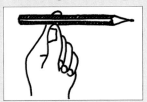

Viewing actual length

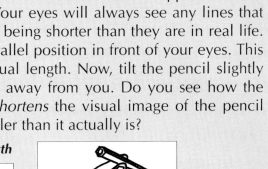

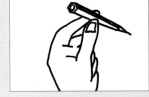

Viewing foreshortened length

▲ Drawings of a pencil in parallel and inclined positions.

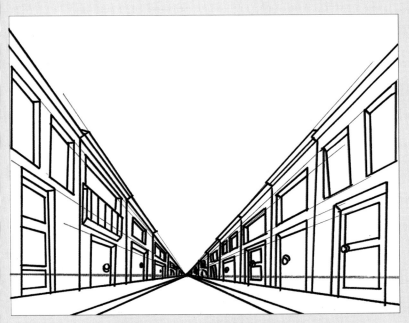

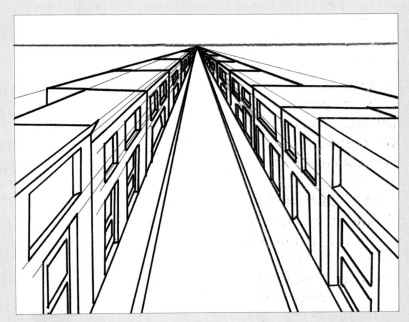

◀▶ Have some fun playing with the horizon line. Place it higher or lower and watch the view of your street change. Draw the horizon line closer to the bottom and your drawing appears to have the viewpoint of a little child; put it near the top of the paper and you will create a bird's-eye view.

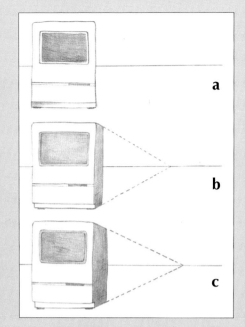

a

b

c

So far, you have only made vertical movements—up and down—in front of the object you are drawing.

What happens when you move horizontally, that is from side to side? Place yourself in front of a box—or an object with a boxlike shape, such as a TV or a computer monitor. View it from the right side, then from the left. What do you see?

Standing squarely in front of your TV, you will not be able to see its sides because their vanishing point is hidden directly behind the TV set **(a)**. Move sideways a little toward the right and you will see a small part of its side; with this view, the vanishing point is near the object **(b)**. The farther to the right you move, the more you will see of the object's side and the wider will be the distance between the object and the vanishing point **(c)**.

► All the views you have been working with up to now have been from a position parallel to the object. Suppose, however, that none of the sides you are looking at run along horizontal lines. This case is where a second vanishing point comes into play. Once more, use your dresser as a model. Stand in front of one of its corner edges, so that you are able to see two of its sides equally.

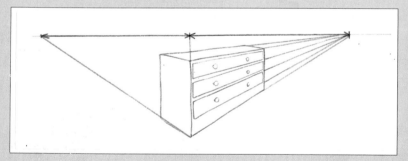

◄ Notice that each side of the dresser has lines that meet at different vanishing points.

► **Changing position to the right.** Moving slightly to the right will give you a fuller view of the front of the dresser. The vanishing point to the right of the edge will also move further away, whereas that of the left will draw nearer to the corner edge of the dresser.

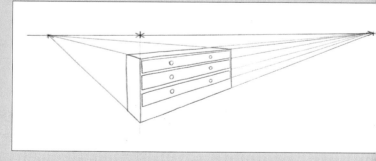

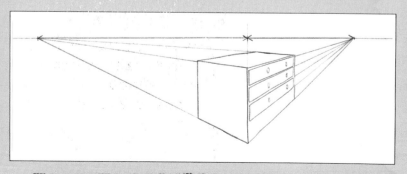

◄ **Changing position to the left.** If you move in the opposite direction and stand slightly off-center to the left, you will see the left vanishing point move further away.

The perspective system you have just been introduced to will help you in creating depth in your landscape drawings. Nevertheless, this is not the only way to capture three-dimensional space. You can also use color to differentiate distant objects from those nearer to you. Objects painted in warm tones—red, orange, yellow, brown—seem to be closer to the viewer. Those painted with cool tones—blue, purple, green—appear to be farther away.

▶ You can also use an effect similar to that seen in a photograph. Draw near-by objects with clear, well-defined lines and distant objects with less distinct lines.

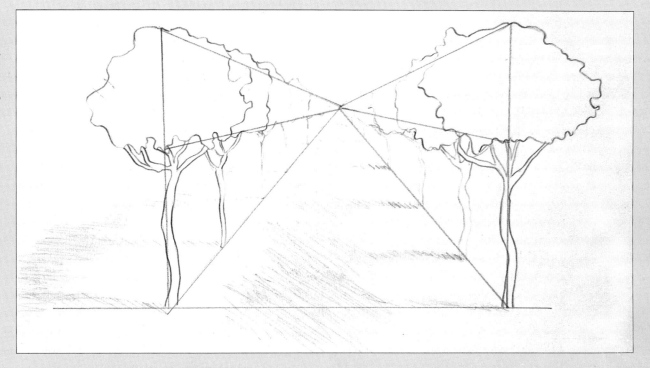

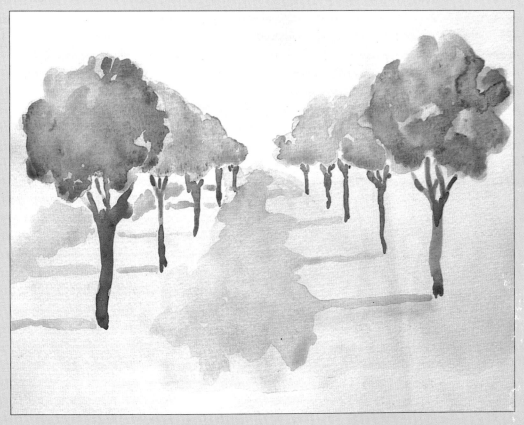

◀ Combining perspective with the last two techniques will let you create more realistic and expressive drawings.

A Street Scene Collage with Patterned Paper

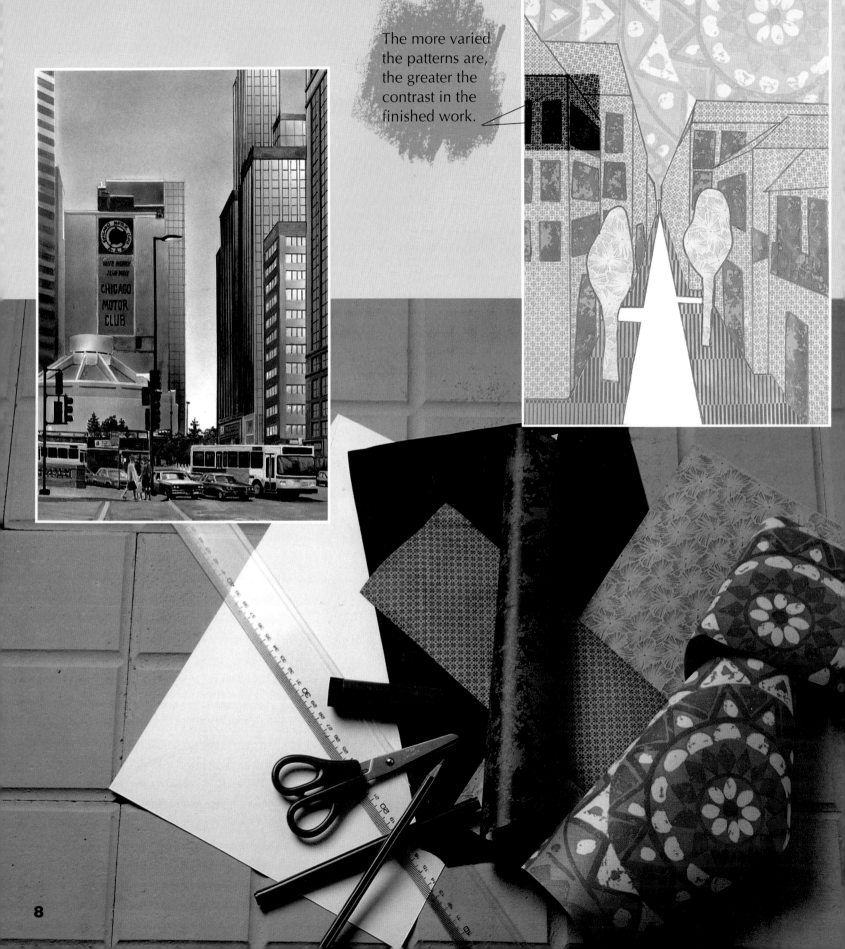

The more varied the patterns are, the greater the contrast in the finished work.

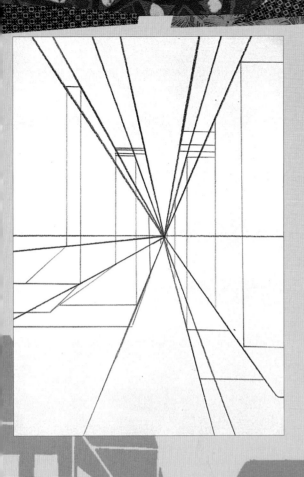

1 Draw the perspective, which in this case has one vanishing point.

2 Sketch the buildings.

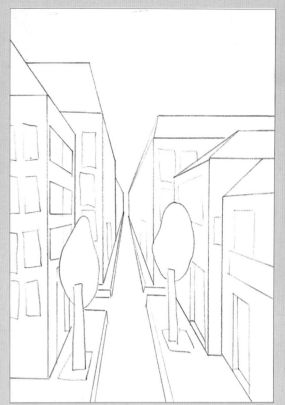

Useful Tips

When working with patterned paper, it is better to spread the glue on the background support. This will help you avoid accidentally creasing the patterned paper.

3 Trace the drawing on a separate sheet of paper to use it as a *template* for the shape of each element. Next, cut out each shape, being sure to place the patterned paper under each template.

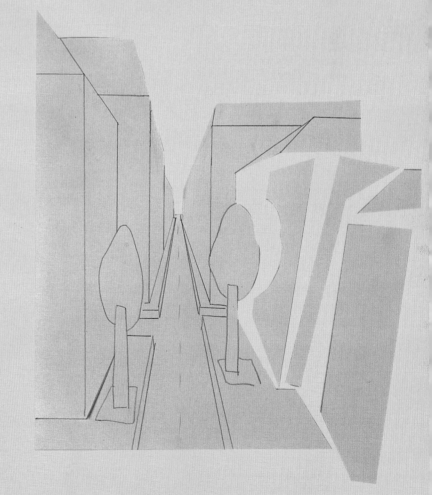

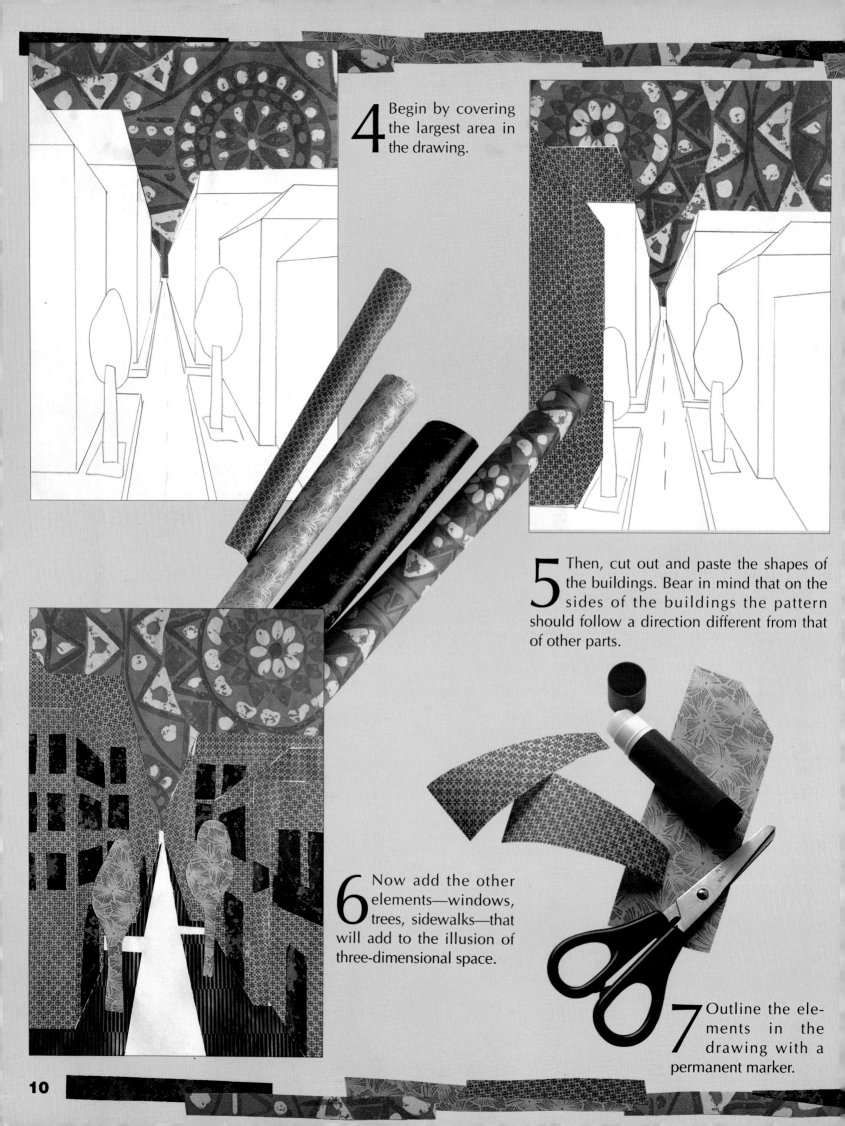

4 Begin by covering the largest area in the drawing.

5 Then, cut out and paste the shapes of the buildings. Bear in mind that on the sides of the buildings the pattern should follow a direction different from that of other parts.

6 Now add the other elements—windows, trees, sidewalks—that will add to the illusion of three-dimensional space.

7 Outline the elements in the drawing with a permanent marker.

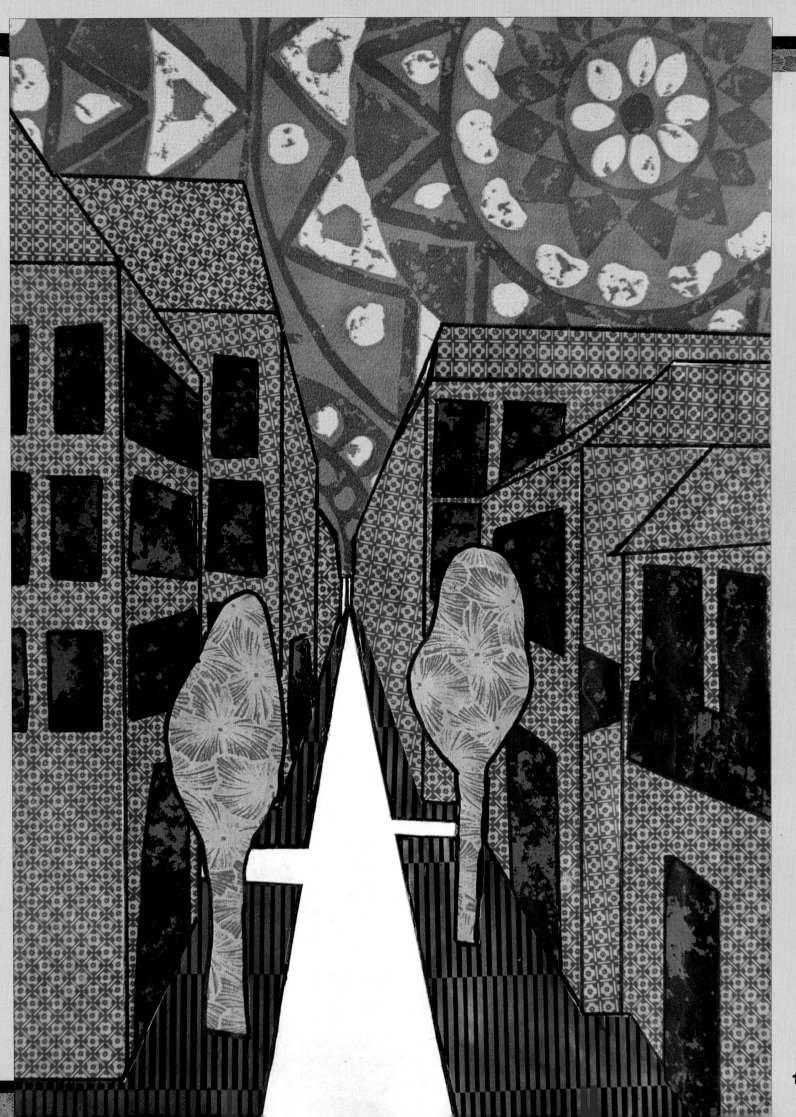

A River and Footbridge in Monochrome with Dry Materials

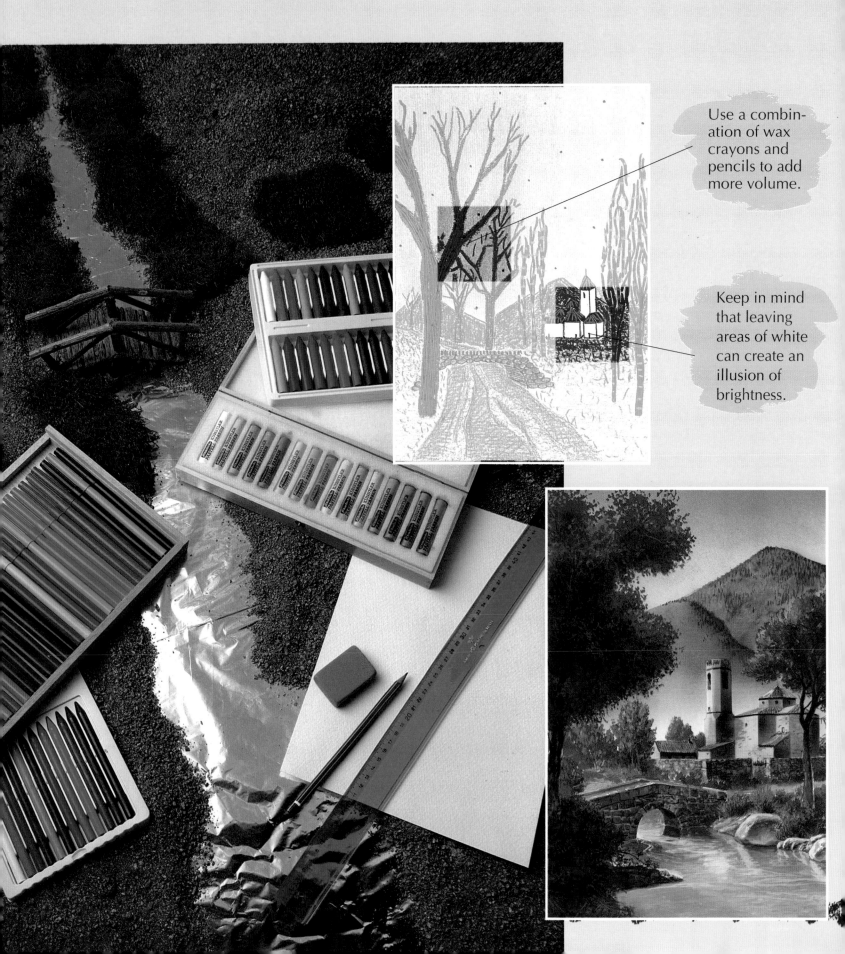

Use a combination of wax crayons and pencils to add more volume.

Keep in mind that leaving areas of white can create an illusion of brightness.

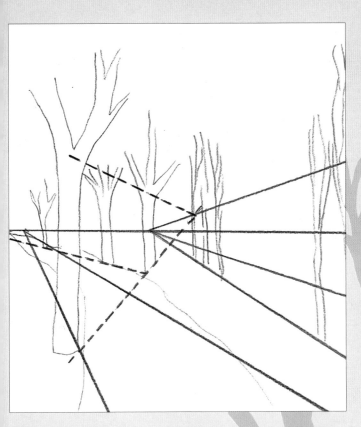

1 Landscape with a two-point perspective.

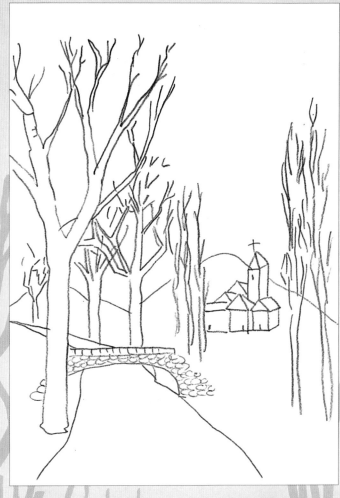

2 Sketch your drawing paying close attention to the scale of the elements. That is, the trees and bushes in the foreground will have to be larger than the elements in the middle and background of the drawing.

Useful Tips

When choosing a color, select one with the widest range of tones.

3 Select a color, for example violet, and use the same tone in all the dry materials that you have (wax crayons, pastel, coloring pencil, and so on).

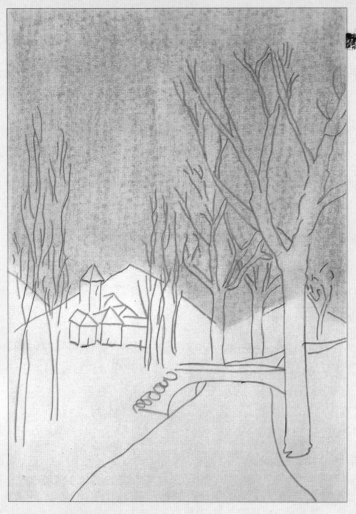

5 First, color the background in a light tone. Use pastel to create an even tone.

4 Try different combinations of these materials. Here are some examples:

a) Pastel and fine-point marker
b) Pastel and crayon

 a b

c) Colored pencil and wide marker
d) Crayon and wide marker

 c d

e) Wide marker and pastel
f) Crayon and colored pencil

 e f

g) Crayon and wide marker
h) Wide marker and fine-point marker

 g h

6 Work the other elements with different materials.

7 Add whatever patterns or *textures* you have created on top of the flat colors you applied previously.

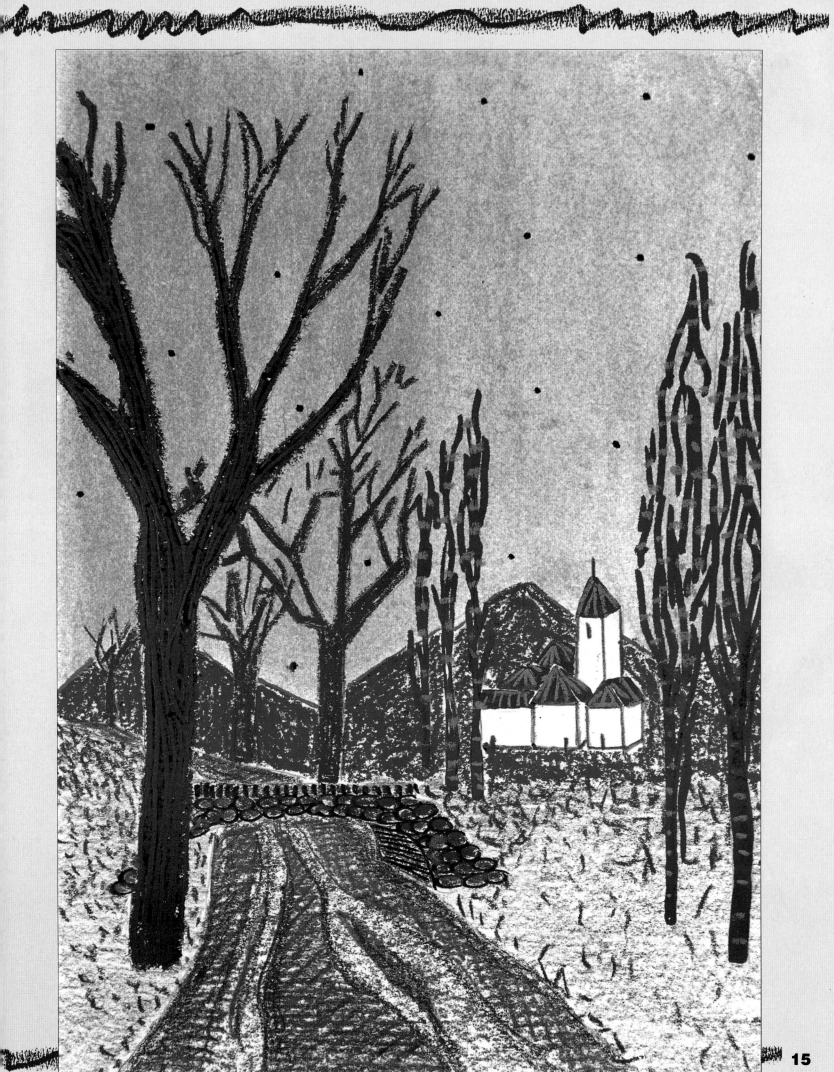

An Alley on Watercolor Paper with India Ink

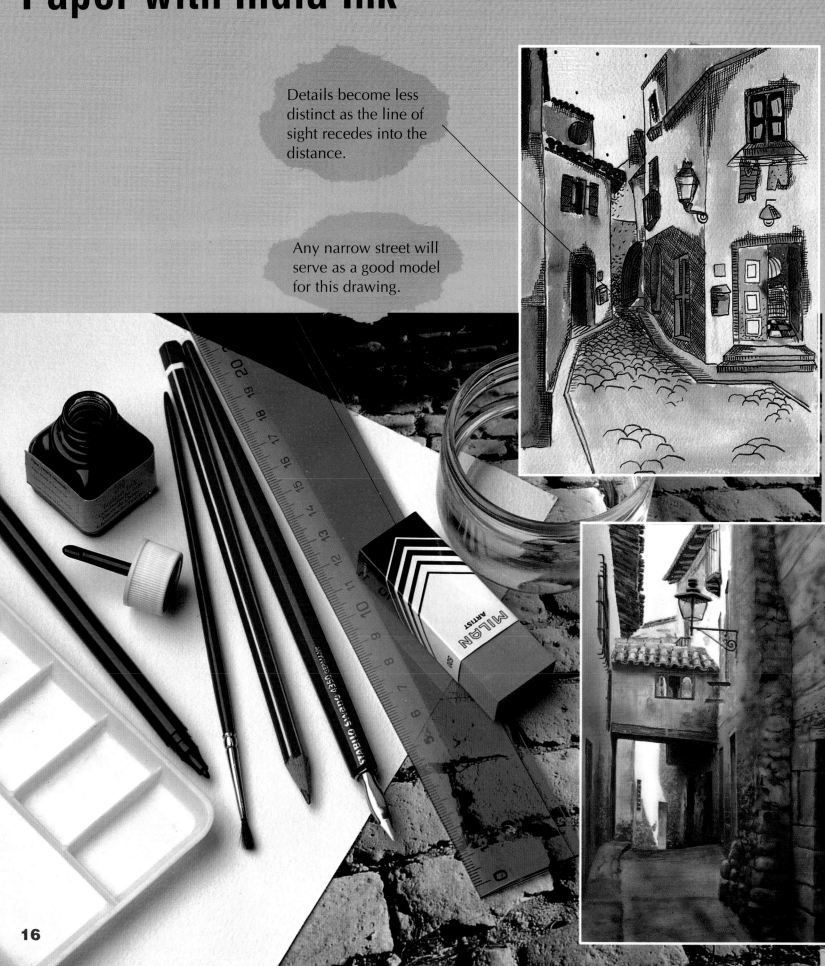

Details become less distinct as the line of sight recedes into the distance.

Any narrow street will serve as a good model for this drawing.

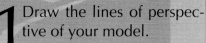 Draw the lines of perspective of your model.

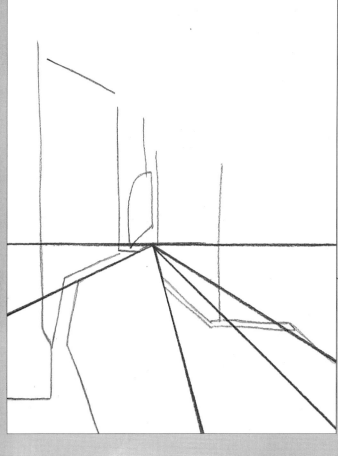

Materials and Techniques

To keep the sheet of watercolor paper from curling when you begin painting, you first need to attach it to a wooden board or some other rigid support. Fasten all four sides of the paper to the board with tacks or masking tape. Next, dampen the paper by applying water to the surface with a brush. Allow it to dry, and then you can start painting.

2 Sketch the drawing, and remember that the lines of perspective of windows, doors, and other elements located on walls with a vanishing point will also vanish.

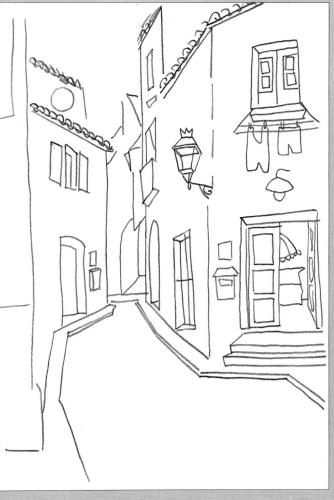

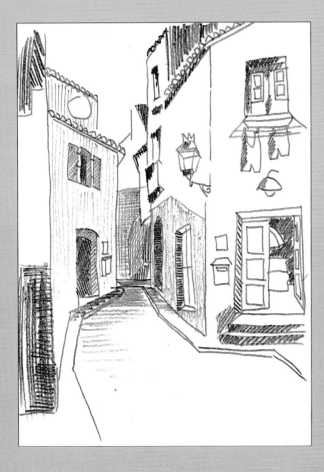

3 Make a sketch or two, imagining different directions for the light and changing the shadows and highlights accordingly.

4 Dilute the India ink with water and create a palette of the different gray tones you plan to use.

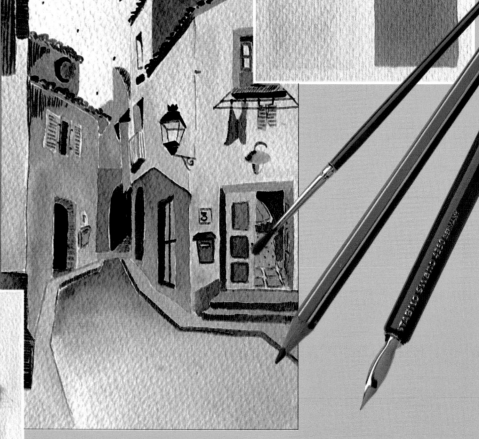

5 The first approach to applying the colors is to paint each part of the drawing with one tone and allow it to dry before painting it with a second tone.

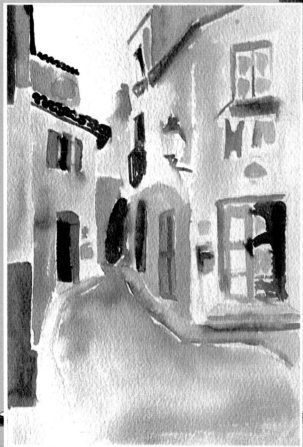

6 Or you can paint all the elements at once, without regard to the blending that occurs when each wet tone comes in contact with the others.

7 After the drawing is completely dry, put in the details with a fine brush, fine-nib marker, pen, or other tool.

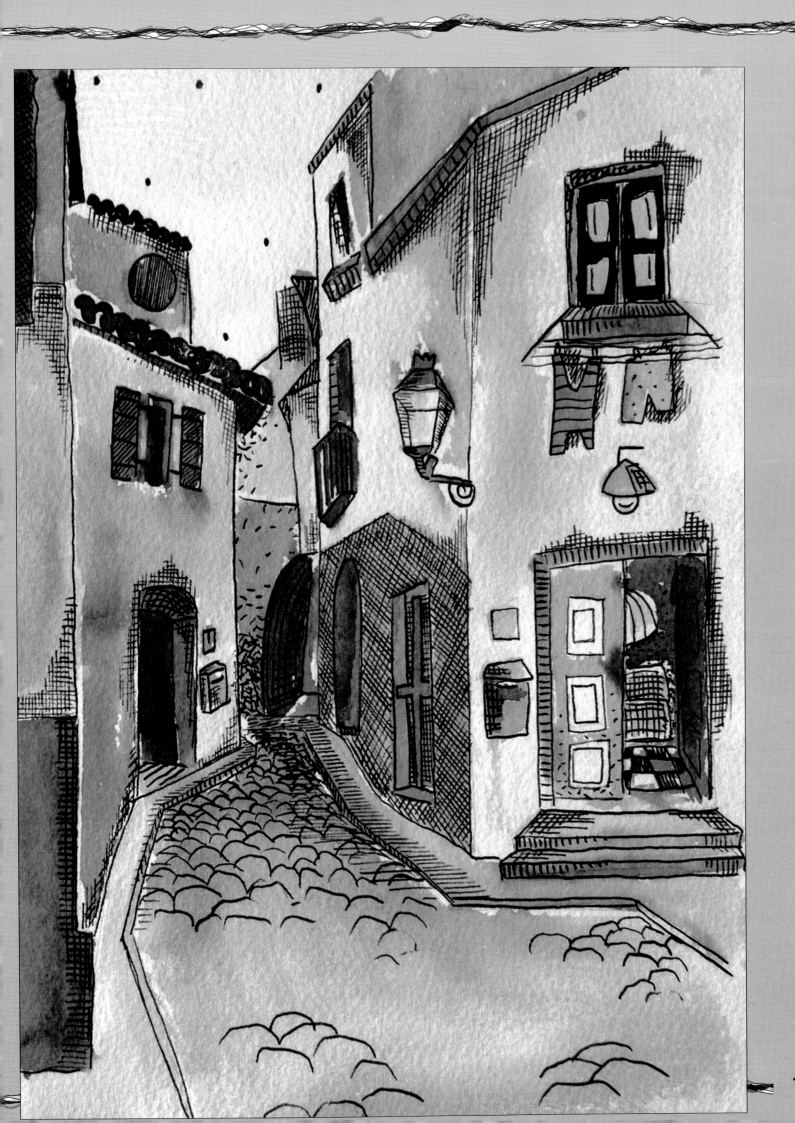

An Island in Pointillist Style

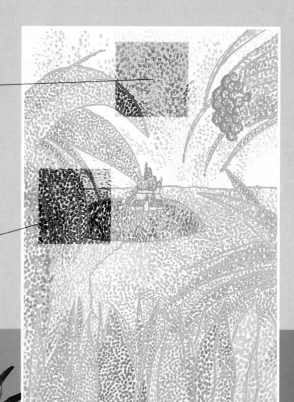

You can choose any subject with wide areas of open space.

Combine colors in the same range to give your work tonal richness.

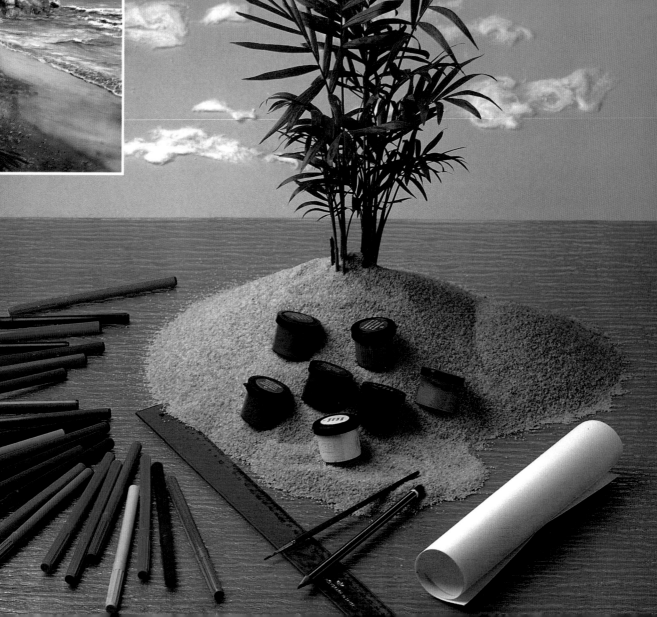

Materials and Techniques

The *pointillist* technique is perfect for using markers, which give it a cleaner, more defined finish.

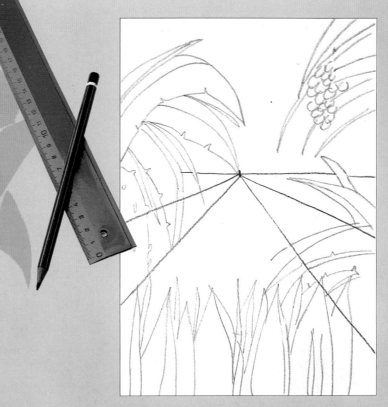

1 Make a sketch of your model and draw the lines of perspective.

2 Next, try suggesting perspective through the relative size of the elements in the drawing: Leaves and vegetation in the foreground appear larger than the objects in the middle plane of the scene (building and beach).

3 Create different pointillist techniques with acrylic paints. For example: **(a)** Apply a single color to the background and, after it dries, add a darker tone. **(b)** Select two tones and apply them alternately so the hues will blend. **(c)** Paint the entire background in one color; allow the area to dry, then apply another color of the same range, but in a darker tone. **(d)** Paint the background in a light color and add a darker tone on top to suggest shadows that carry more contrast than that shown in example *a*. **(e)** Use tonal *gradation;* here, orange has been added to yellow. **(f)** Apply two layers of paint; first a light tone, and without waiting for the paint to dry, follow that with a different tone.

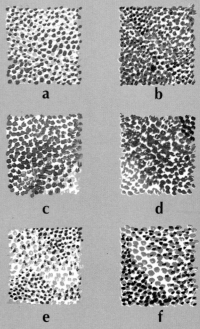

a b

c d

e f

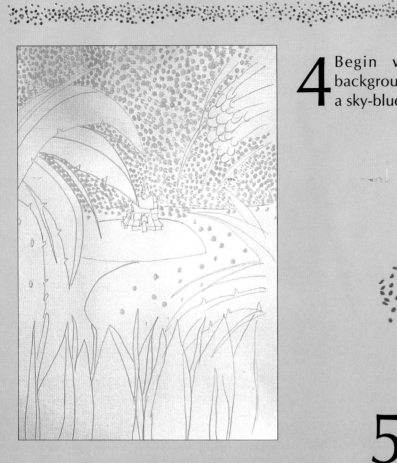

4 Begin with the background, using a sky-blue tone.

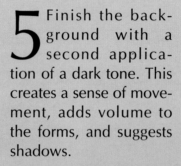

5 Finish the background with a second application of a dark tone. This creates a sense of movement, adds volume to the forms, and suggests shadows.

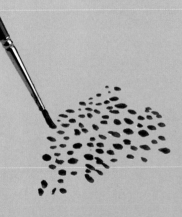

6 Work all other areas in the same way.

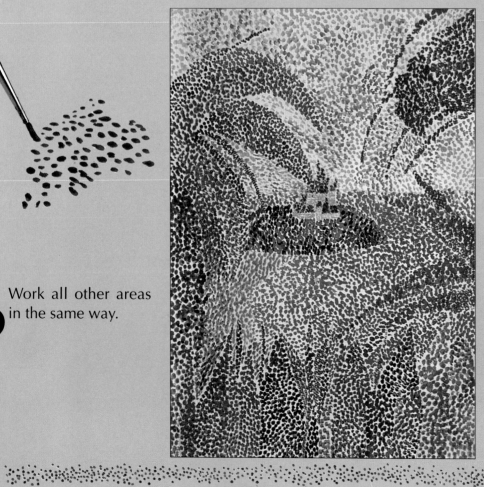

7 If you like the effect you now have, omit this step. Otherwise, add details to some elements in your drawing with a fine brush.

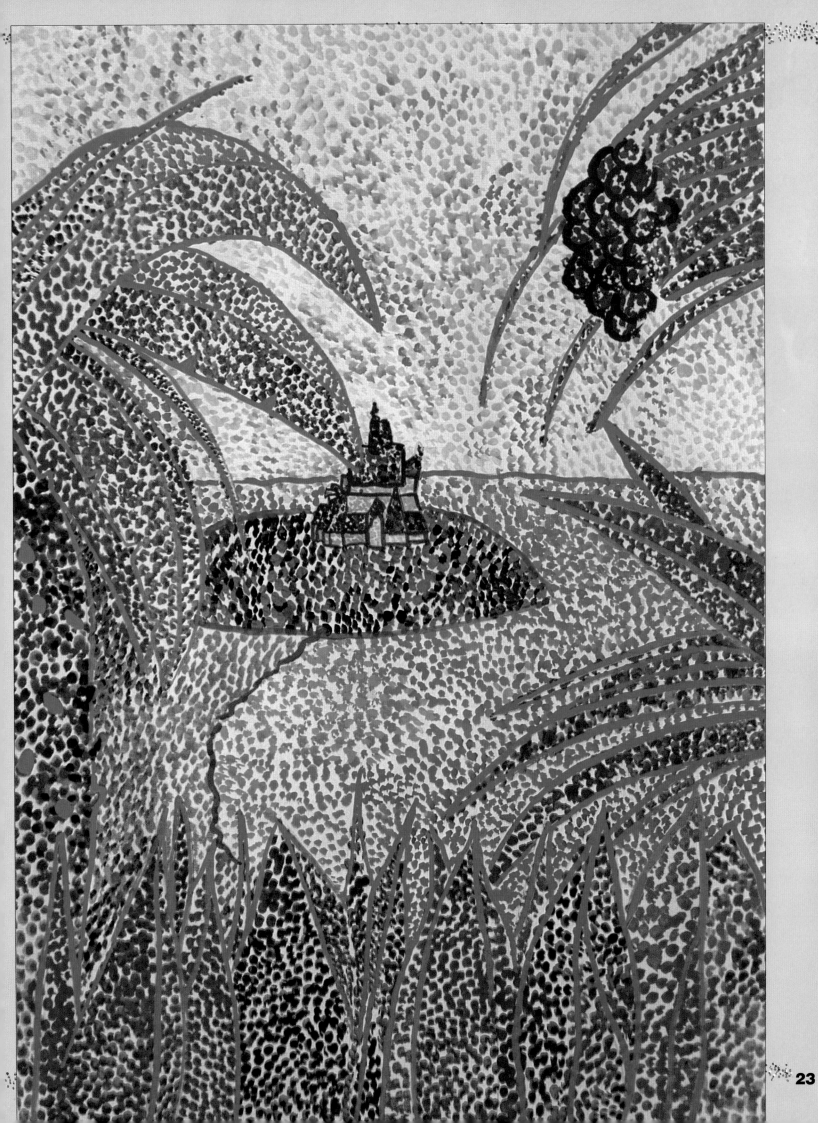

Pastel Roofs on Brown Wrapping Paper

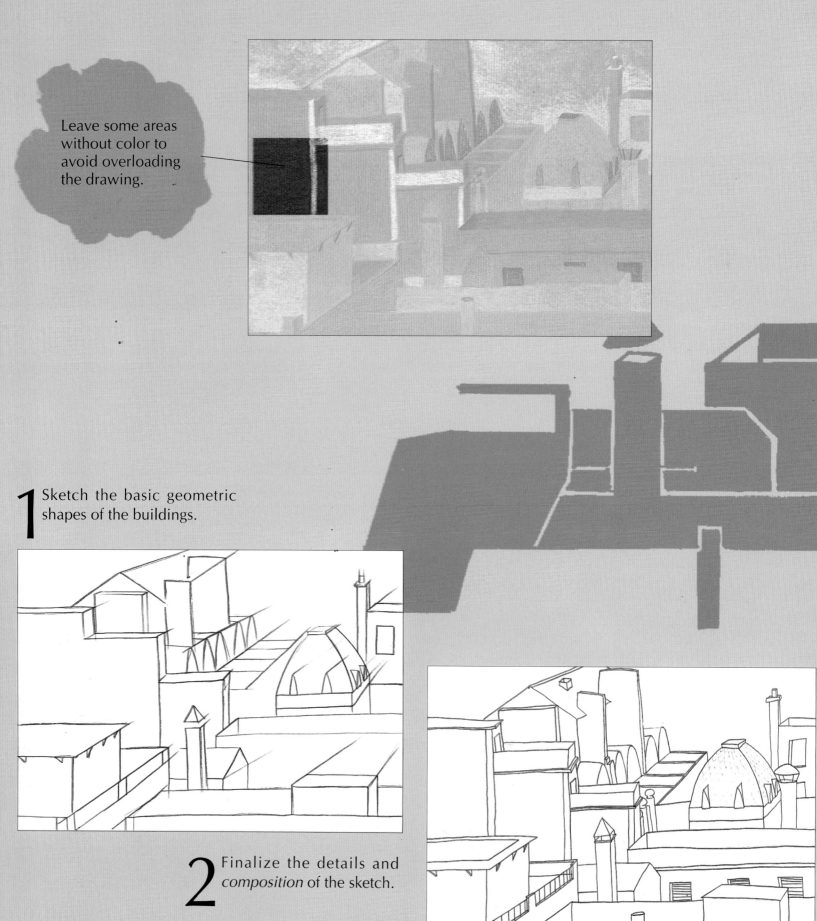

Leave some areas without color to avoid overloading the drawing.

1 Sketch the basic geometric shapes of the buildings.

2 Finalize the details and *composition* of the sketch.

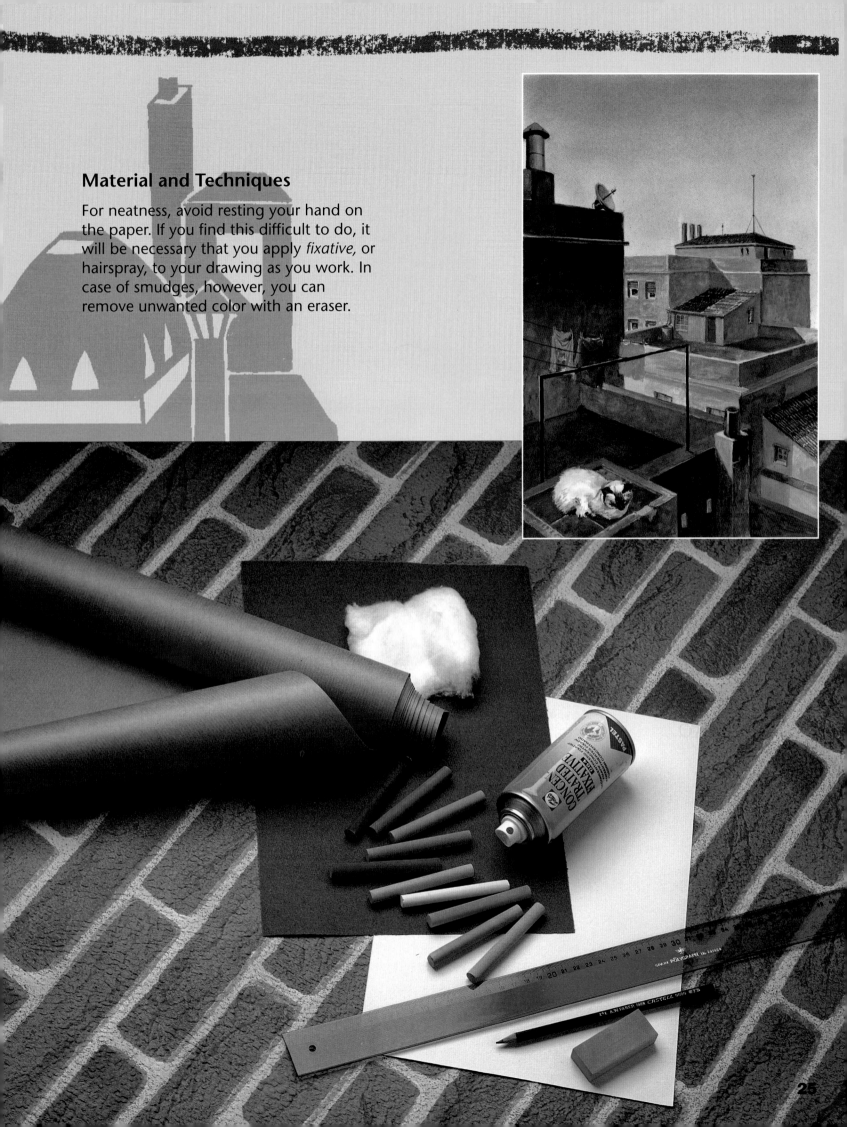

Material and Techniques

For neatness, avoid resting your hand on the paper. If you find this difficult to do, it will be necessary that you apply *fixative*, or hairspray, to your drawing as you work. In case of smudges, however, you can remove unwanted color with an eraser.

3 Select a limited range of colors. Here, only three have been used: green, orange, and pink, with an additional two tones of each color.

4 Before applying the color to your drawing, decide where light is coming from. In these illustrations, the light is from the front, as the arrow indicates. The color of the front walls of the buildings, therefore, are lighter than those of the side walls.

5 To avoid confusion, start by painting the light walls first with the colors you selected. Keeping a sharp point on your pastels will let you draw with more precision, so sharpen them by rubbing the tips on sandpaper.

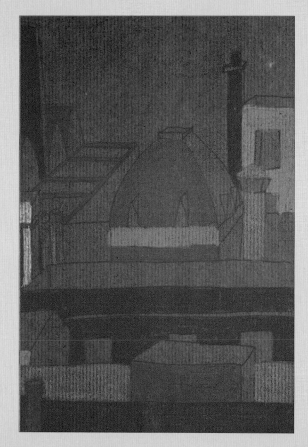

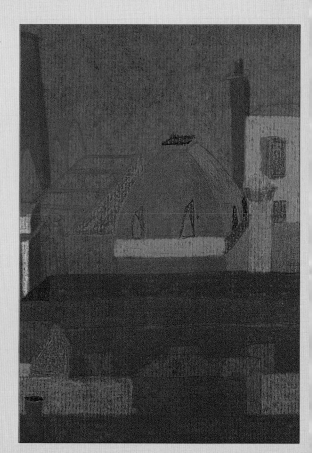

6 Next, paint the side walls with a tone darker than the first.

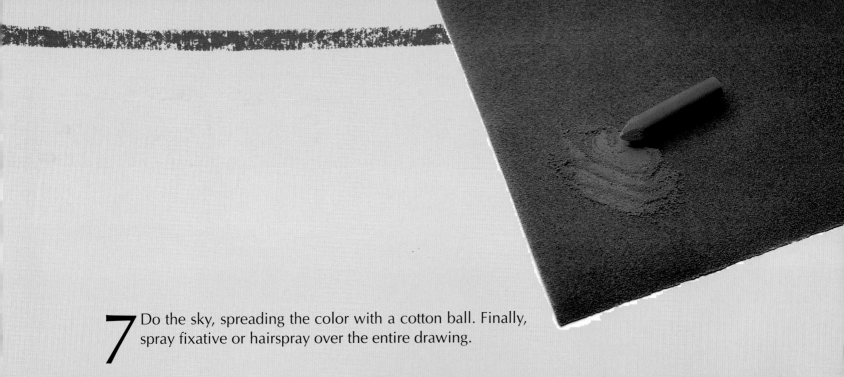

7 Do the sky, spreading the color with a cotton ball. Finally, spray fixative or hairspray over the entire drawing.

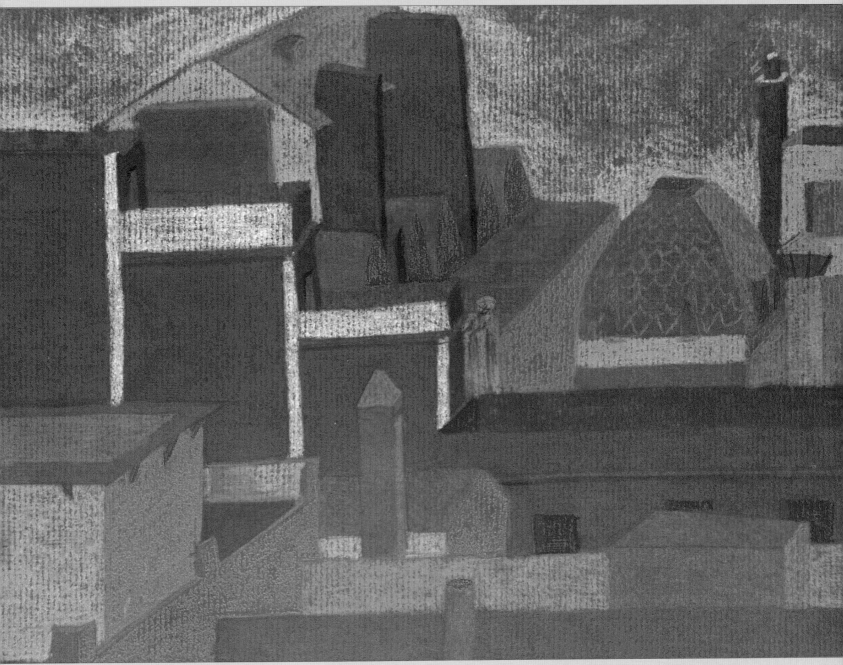

A Lemon Tree with Texture in Tempera

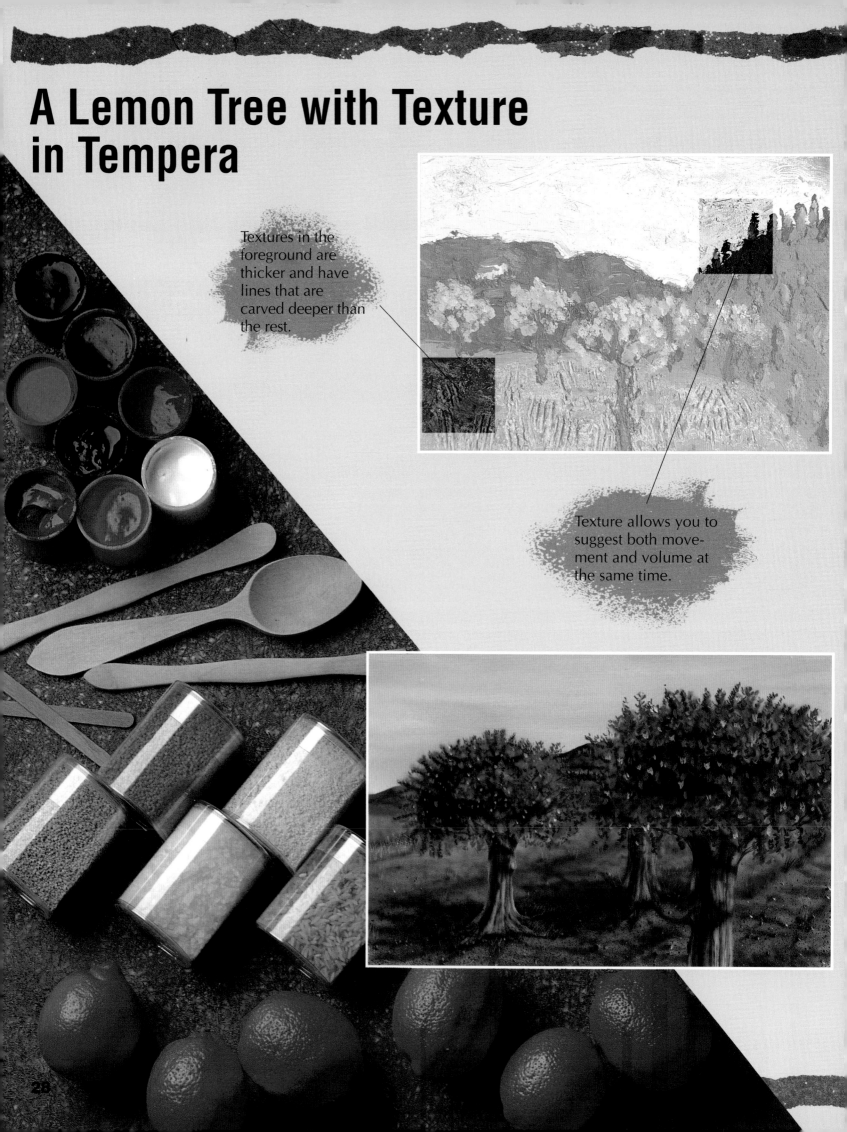

Textures in the foreground are thicker and have lines that are carved deeper than the rest.

Texture allows you to suggest both movement and volume at the same time.

1 Draw a landscape. This one has trees in the foreground, mountains in the middle, and the sky in the background.

Materials and Techniques

In mixing the paints with the dry materials, use the coarser granules for the near and middle planes, reserving the finer ones for the distant plane. The different textures will lend realism to the landscape.

2 Transfer the drawing to a rigid support.

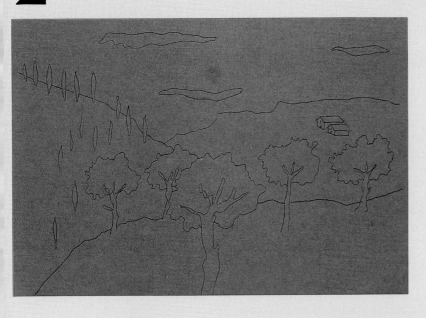

3 Select different materials to texturize the paint. Bran, sand, salt, and powdered laundry detergent are good examples of granular substances that are generally available in the home. Mix them into the tempera and experiment with their effect on a separate piece of paper.

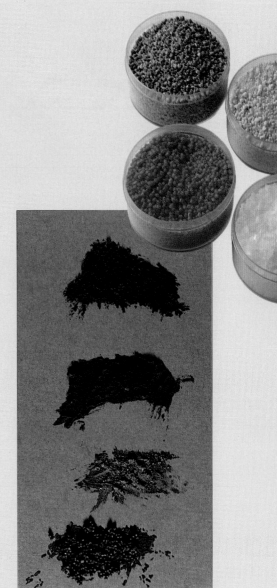

4 In texture work, the material you use and the method with which you apply it are equally important. Try using a wooden spoon, a spatula with a blunt end and one with a pointed end, wooden sticks, and so on.

5 The mountain in the middle ground has been covered with paint texturized with sand.

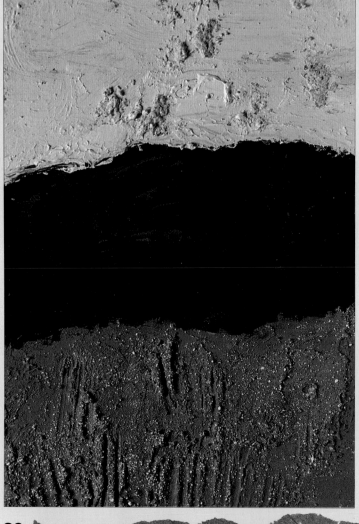

6 Paints have been mixed with salt for the background sky and with soap powder for the field in the foreground.

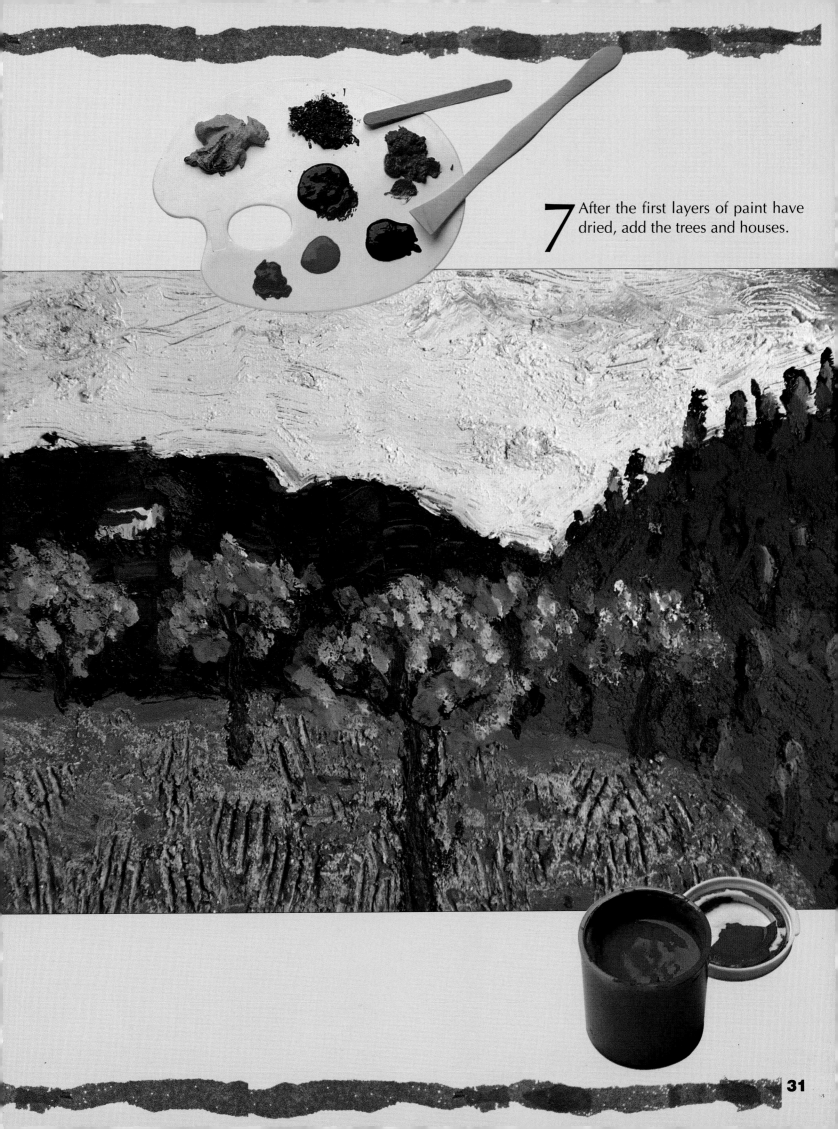

7 After the first layers of paint have dried, add the trees and houses.

A Palm Tree Using Masking Fluid and Watercolors

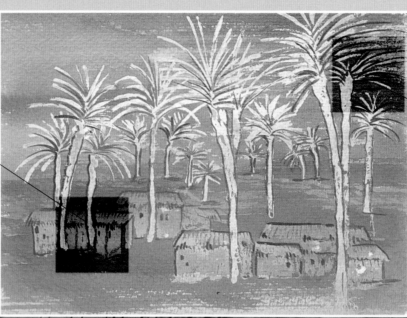

Before reserving your highlights with the masking fluid, decide where the light is coming from.

Overlap some images to add to the illusion of a third dimension.

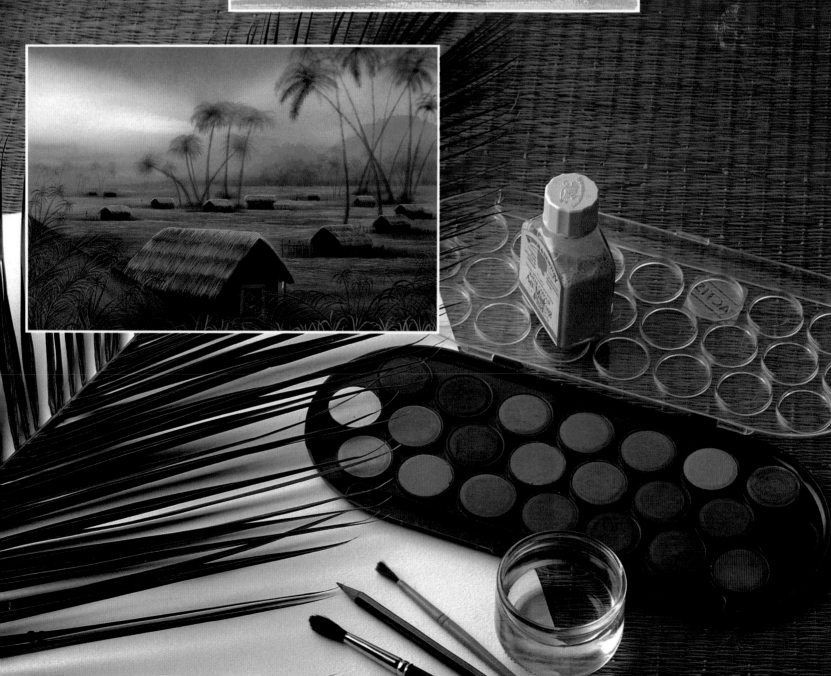

1 Establish perspective by varying the size of the palms. Trees in the foreground need to be larger than the trees in the background, which must gradually get smaller according to the receding lines of perspective. Choose a subject that will allow you to *reserve* some areas that will remain without color (other than the white of the paper).

Useful Tips

Variety in texture will make the drawing richer and more appealing. Look for several objects with different textures and test their effect for use in the drawing.

2 Paint the trees with the masking fluid.

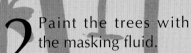

3 Then, apply a *wash* of watercolor to the entire surface of the paper.

4 Without removing the first application of masking fluid, use the fluid again to *mask* the forms of the houses in the drawing. Allow the fluid on the paper to dry.

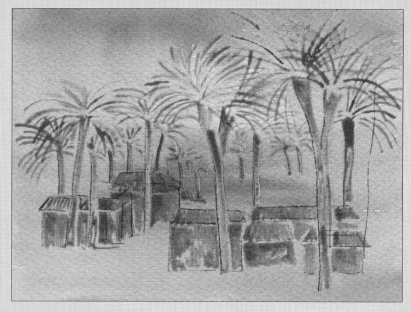

5 Apply a second wash of a more intense color to the entire surface of the sheet. Wait for the paint to dry and then remove the mask from the paper by rubbing it off with your finger.

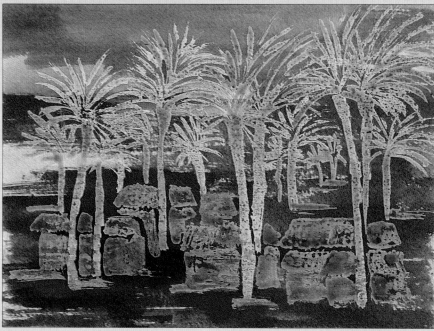

6 If you find that the white color of the first areas you masked bring too much contrast to the drawing, you can tint them with a soft wash of highly diluted watercolor.

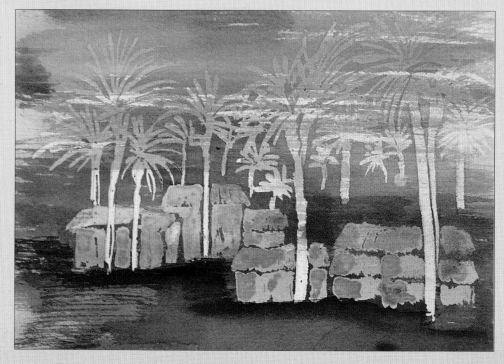

7 After the paint dries completely, use a brush to add a few lines to outline or detail certain elements of your drawing.

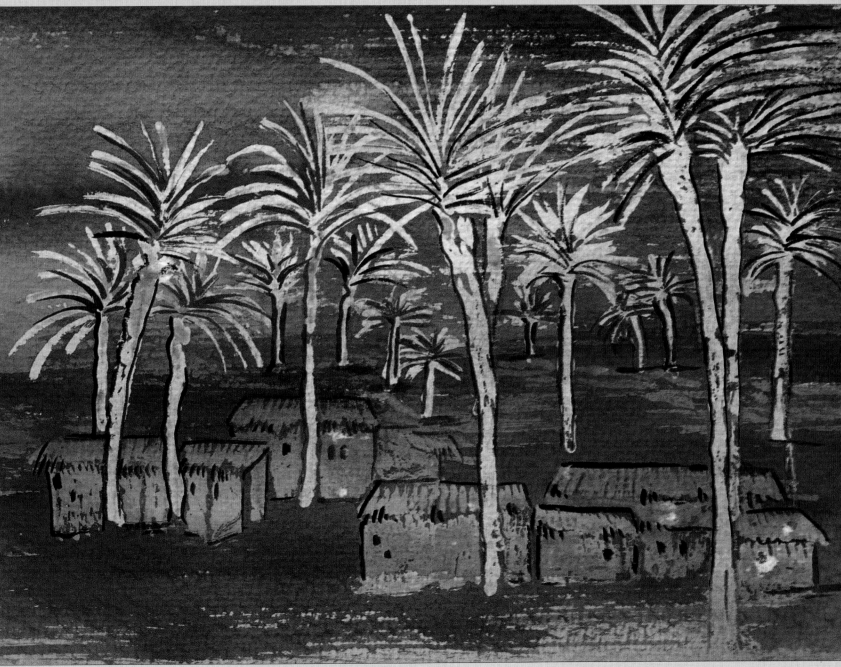

Grape Vines Using Tissue Paper and Real Leaves

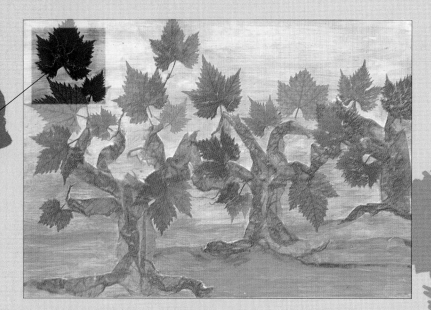

Have some fun collecting different types of leaves from plants or trees.

When coloring, use hues that harmonize with those in the leaves you are going to use.

Materials and Techniques

Use a round-pointed knife to sharpen your wax crayons so your lines will be neat and well defined.

1 You will have to let your leaves dry. Keep them pressed within the pages of a book for about four or five weeks.

2 Draw the trunks of the vines or trees you want in your picture. But be sure that the size of the trunks is in proportion with that of the leaves. Our artist has used grapevines as a subject.

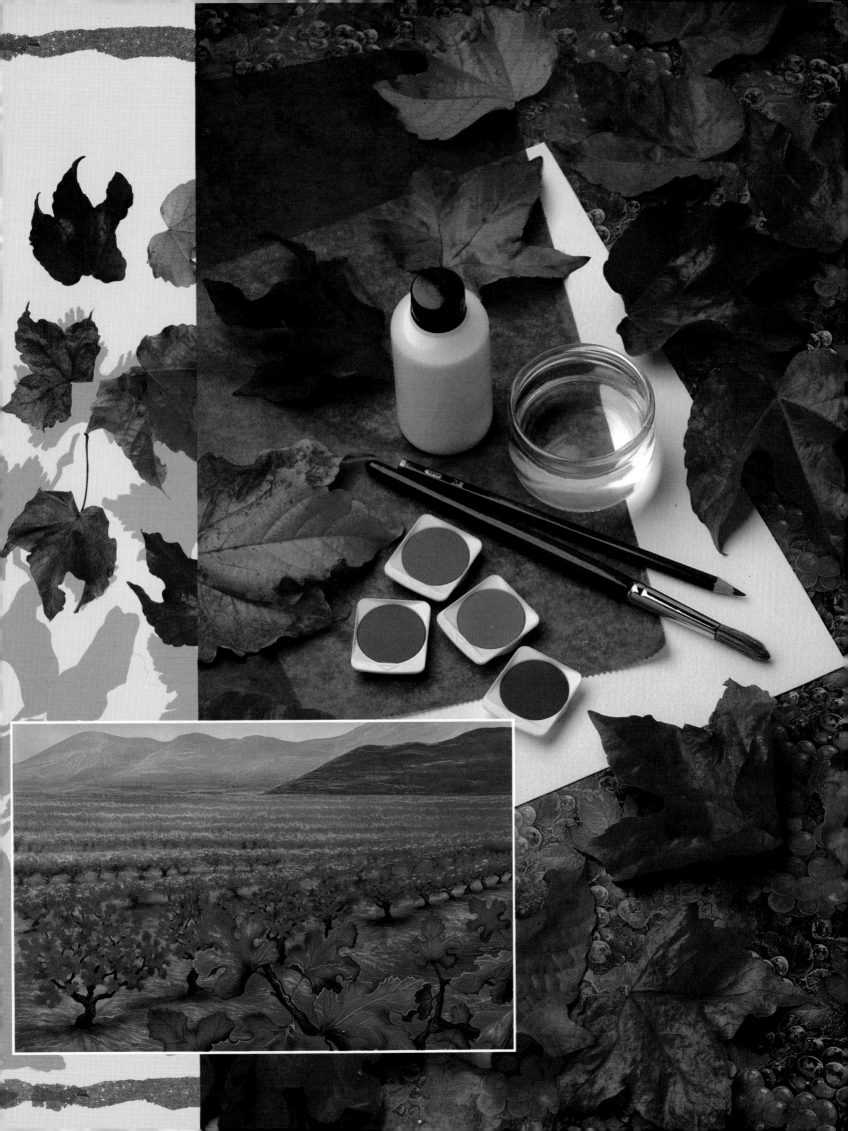

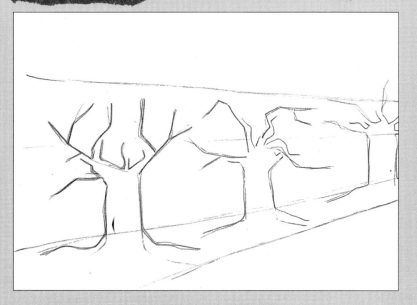

3 Sketch the lines of perspective appropriate to your model, and use the relative size of the objects to suggest depth. Remember that the object nearest to you has to be larger than the most distant one.

4 Cover the trunk by gluing brown tissue paper on it. Making small folds in the paper will suggest the texture of wood.

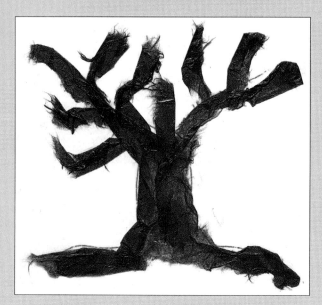

5 Color the background with watercolor paint, adding a little all-purpose white glue to the water.

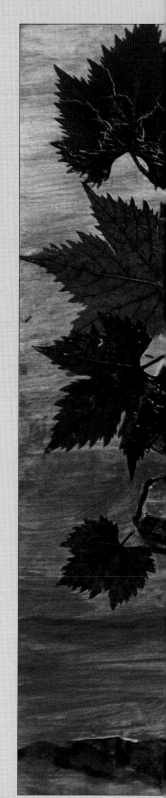

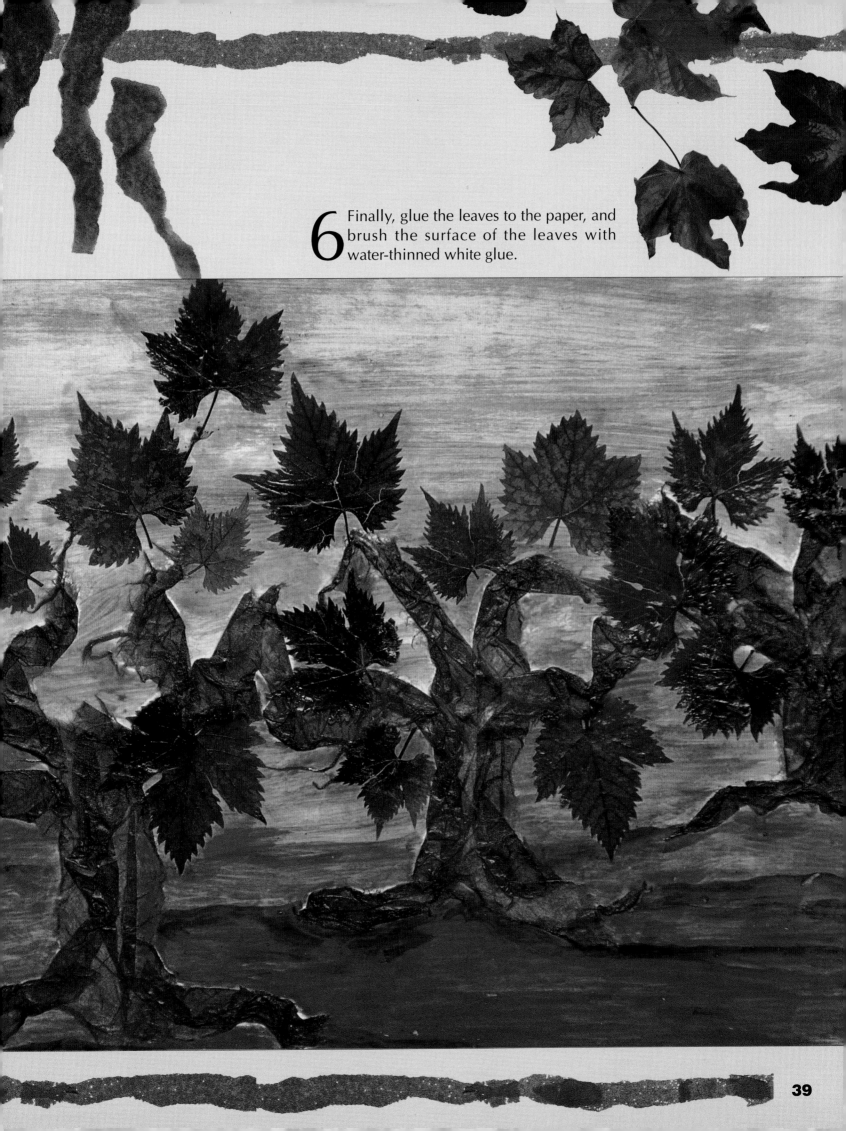

6 Finally, glue the leaves to the paper, and brush the surface of the leaves with water-thinned white glue.

A Sea Created with Colored Shavings

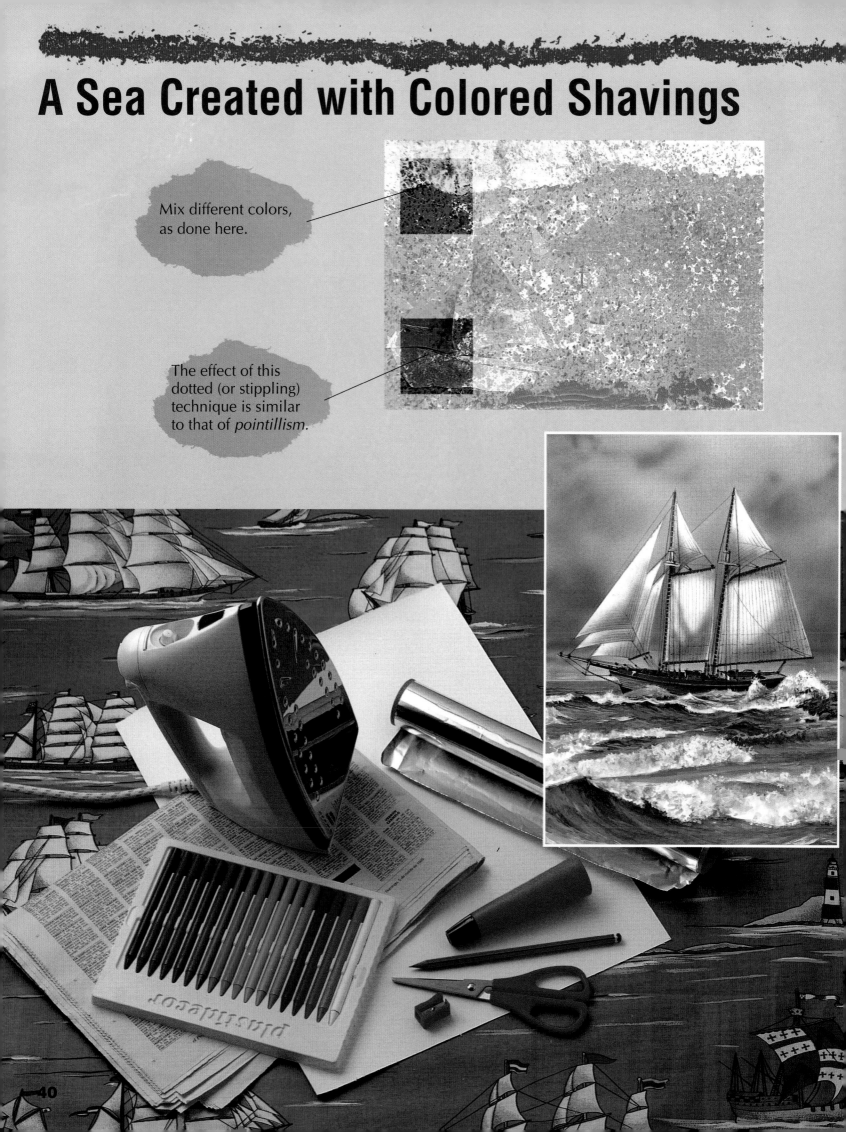

Mix different colors, as done here.

The effect of this dotted (or stippling) technique is similar to that of *pointillism*.

1 This technique requires a drawing without too much detail as it does not allow a precise application of the colors.

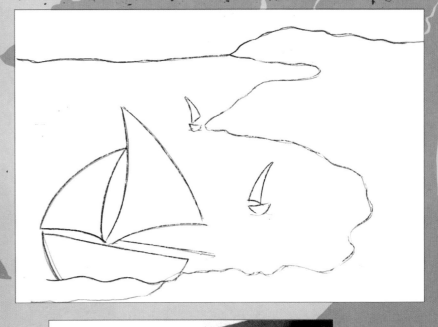

Material and Techniques

Ask an adult to help you with an electric iron. Don't let the iron get too hot—just warm enough to melt the colored shavings when you place it on top of the aluminum paper.

2 Shave pieces of the crayons with a sharpener; break up the shavings into smaller pieces with your fingers. Keep the small piles of shavings separated by color.

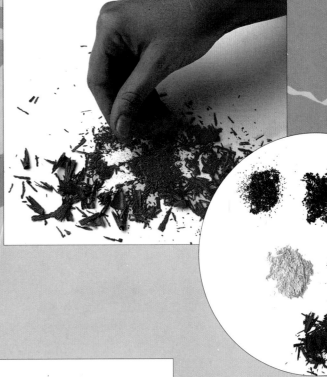

3 First, cover the largest area of the background with shavings in the appropriate color. Cover this area with a piece of aluminum foil and place a warm iron on top of the aluminum until the colored shavings melt. Wait for it to cool, then remove the aluminum foil.

4 Repeat the procedure to color the other areas of the drawing.

5 Prepare a separate sheet of paper in the same way, but use shavings in a color that contrasts with the background of your drawing.

6 In back of this piece of paper, draw a reversed image of the sailboats. Then, cut out the shapes.

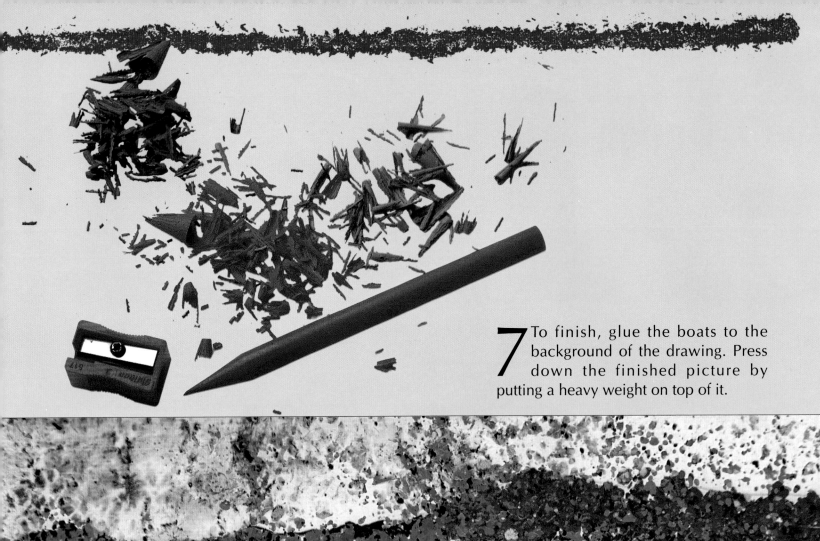

7 To finish, glue the boats to the background of the drawing. Press down the finished picture by putting a heavy weight on top of it.

A Town Modeled with Dough

Find different tools to create a variety of textural patterns. The more instruments you find, the richer your drawing will be.

Use only one pattern for similar elements in the drawing.

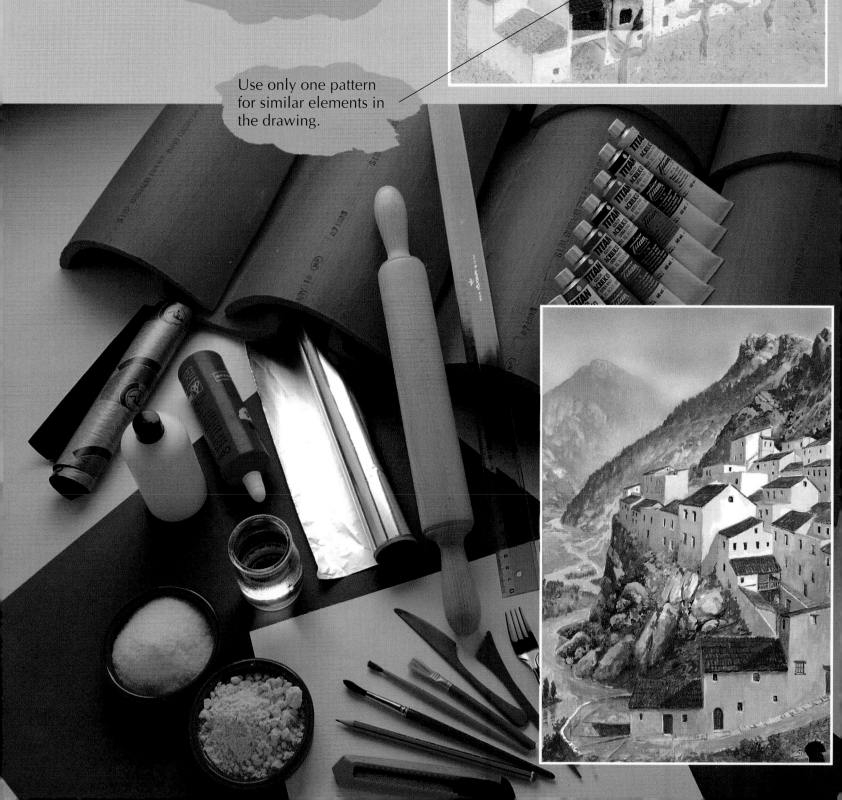

Materials and Techniques

If after preparing your dough you do not have sufficient time to finish the work in the same day, you will have to wrap the dough with a wet cloth to keep it from drying. Then, wrap it with aluminum foil and store it in the refrigerator. To avoid misunderstandings, don't forget to tell an adult that you are working on a modeling project.

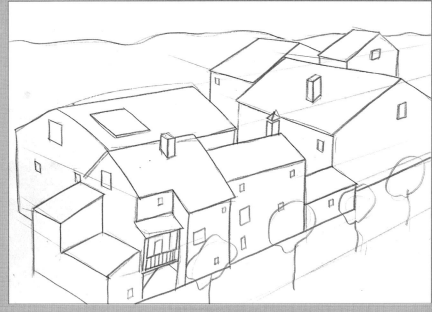

1 Sketch the composition you have in mind. For this technique, a simple theme with little detail is best.

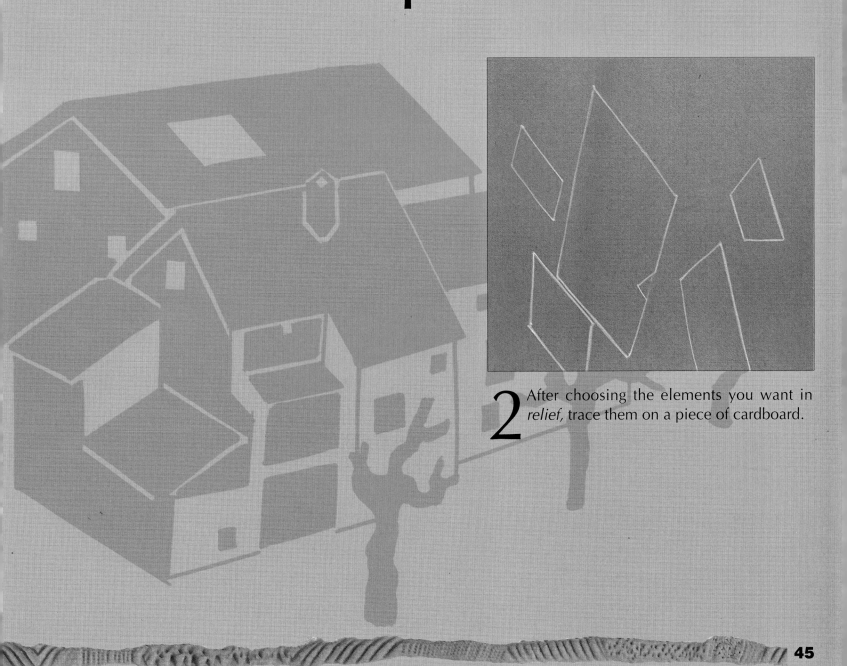

2 After choosing the elements you want in *relief,* trace them on a piece of cardboard.

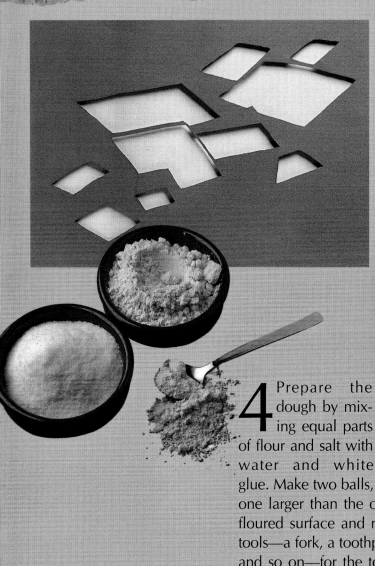

3 Next, cut out the shapes to create a template.

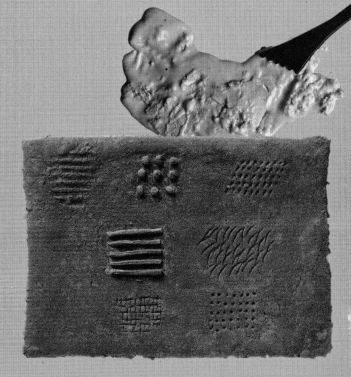

4 Prepare the dough by mixing equal parts of flour and salt with water and white glue. Make two balls, one larger than the other. Turn the small ball of dough onto a floured surface and roll it out with a rolling pin. Test different tools—a fork, a toothpick, the tip of a ballpoint pen, a bent wire, and so on—for the textural patterns you can make with them. When you have decided which patterns you like, knead and roll out the small ball of dough again.

5 Place your template on top of the flat dough and cut the shapes out of the dough with a spatula. After cutting them, mark the shapes with the pattern you selected for imitating the texture of roof tiles for the houses. Roll out the large ball of dough and cut it to create a sheet that fits the *format* of your initial drawing. This sheet of dough will be your support. Use the template to mark the position of the roofs on top of this support; then, with white glue, paste the textured roof pieces in the appropriate areas.

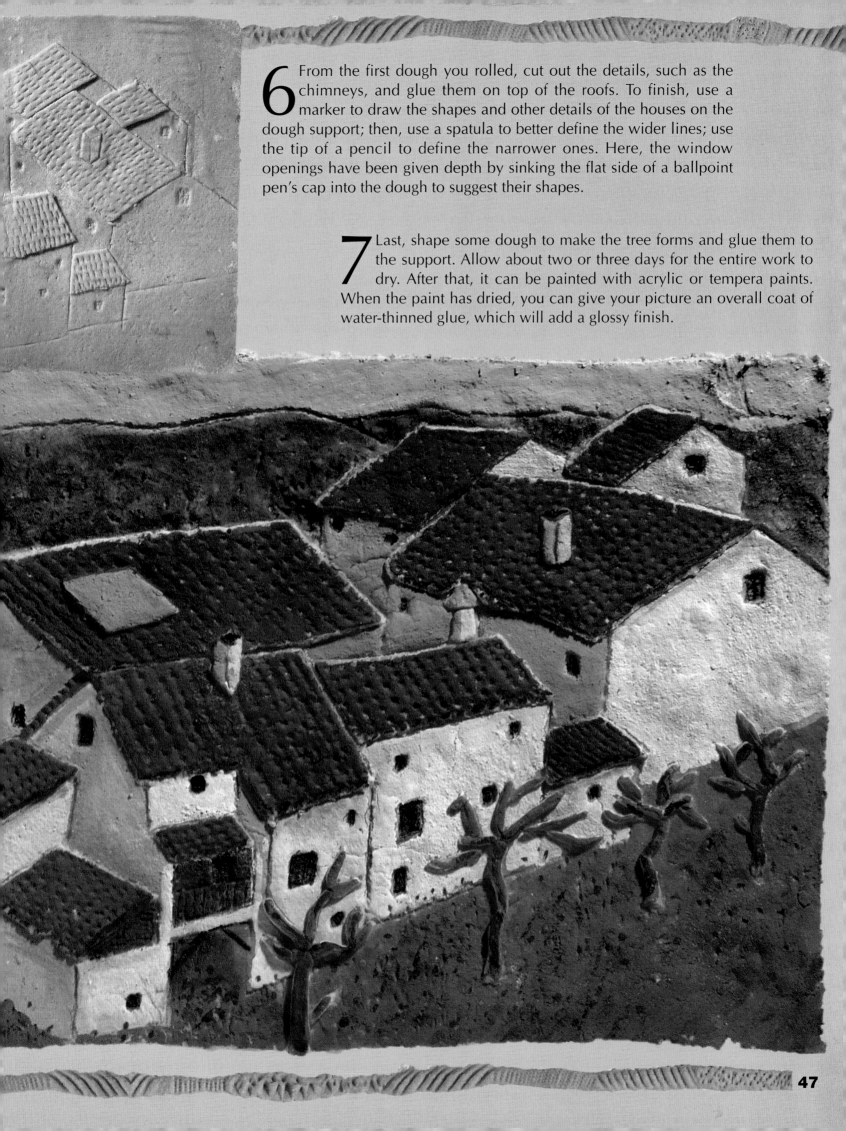

6 From the first dough you rolled, cut out the details, such as the chimneys, and glue them on top of the roofs. To finish, use a marker to draw the shapes and other details of the houses on the dough support; then, use a spatula to better define the wider lines; use the tip of a pencil to define the narrower ones. Here, the window openings have been given depth by sinking the flat side of a ballpoint pen's cap into the dough to suggest their shapes.

7 Last, shape some dough to make the tree forms and glue them to the support. Allow about two or three days for the entire work to dry. After that, it can be painted with acrylic or tempera paints. When the paint has dried, you can give your picture an overall coat of water-thinned glue, which will add a glossy finish.

Glossary

Composition Arrangement of objects in a way that is visually pleasing.

Fixative Varnish or gum resin substance used to protect the surface of a drawing from smudging and from being damaged by moisture. Hairspray can be used as a fixative.

Foreshorten To shorten the visual image of an object, so that the distant parts of the object appear smaller than they really are and those near the observer appear to be larger.

Format Shape and size of a drawing or painting.

Gradation Gradual shift of a color from a dark tone to a lighter one or vice versa.

Horizon line A distant real or imaginary line that stretches across a view and is parallel to the front of the observer's face at eye level. In a drawing, the line across the page that is drawn to represent the observer's point of view.

Linear perspective Theory that artists use in painting landscapes, objects, and living things. It is based on the straight lines that the rays of light follow when they travel to our eye from every point of an object. Through these lines, an observer gains an impression of the size and depth of an object at varying distances and from any point of view. (See *vanishing point.*)

Mask To cover an area of the drawing with masking fluid, or other material, to protect it from being painted.

Pointillism Art theory or style that consists of painting a surface with small dots or strokes of color that blend together when viewed from a distance.

Pointillist Painted in the style of *pointillism.*

Relief Style of sculpting or modeling details of an artistic work so that they project from a surrounding plane surface.

Reserve To leave areas without color so the white of the paper, or other support, will represent the highlights.

Template Piece of paper or cardboard out of which desired elements of a drawing have been cut to serve as a guide or pattern for tracing or molding the forms.

Texture Structure or finish that gives a surface its appearance and feel. It can be crinkled, smooth, rough, etc.

Vanishing point Distant spot at which receding parallel lines in a drawing appear to meet according to the principles of linear perspective.

Wash An overall layer of highly diluted watercolor.

Sketches of the Landscapes

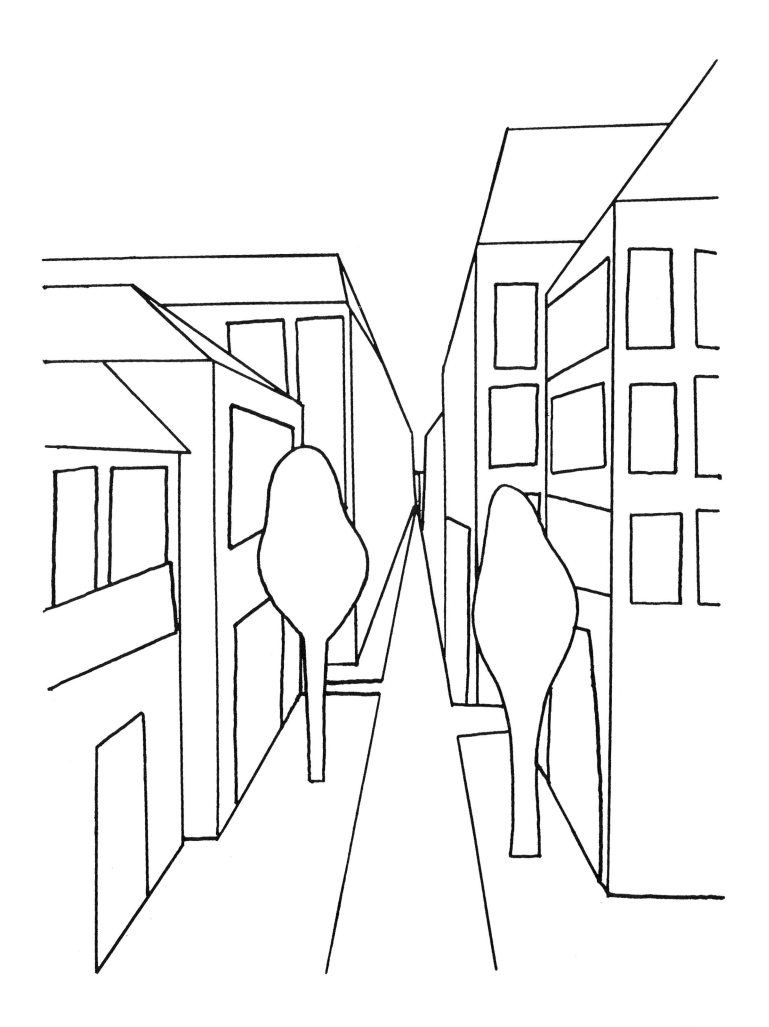

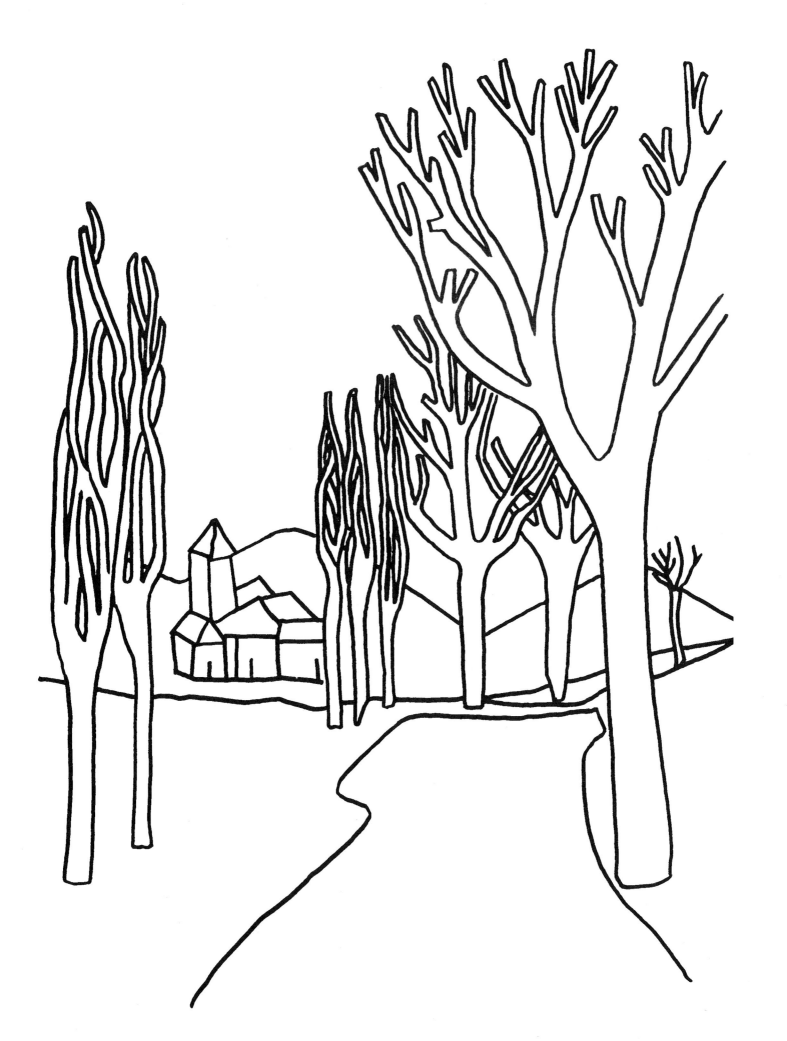

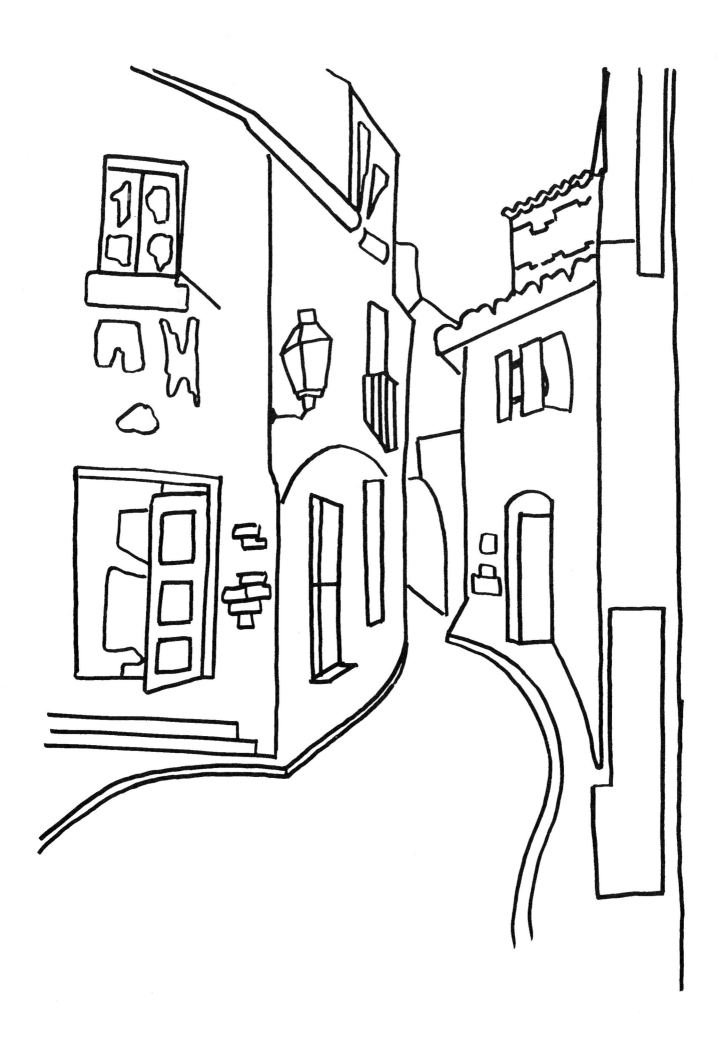

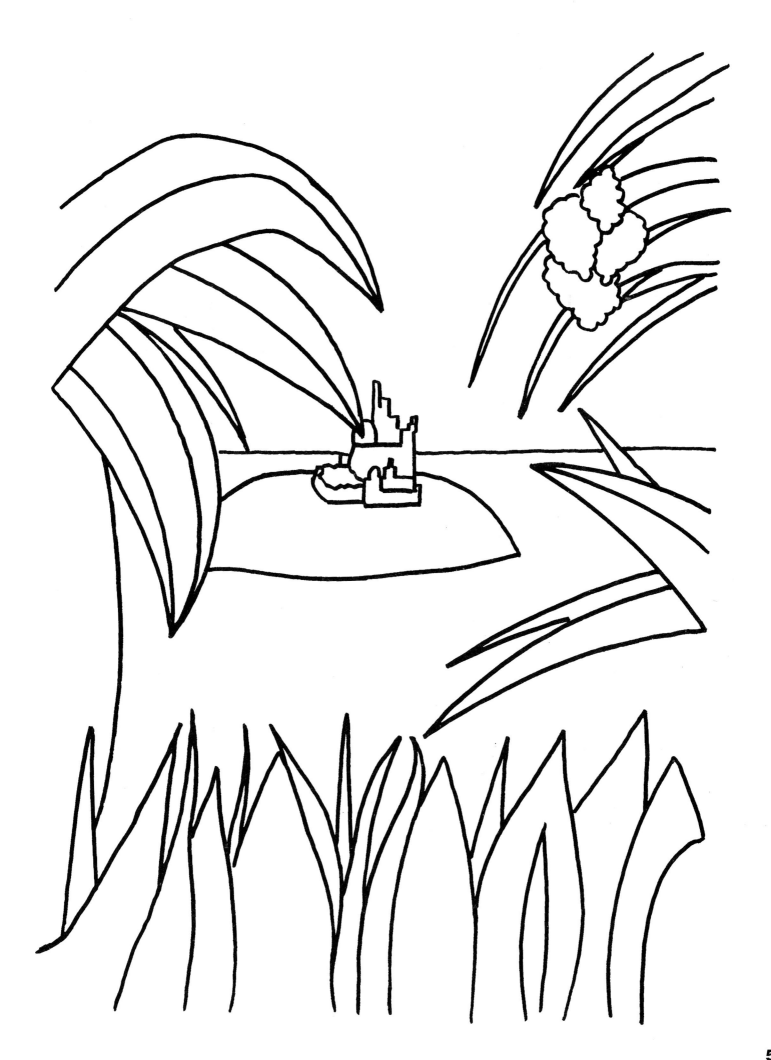

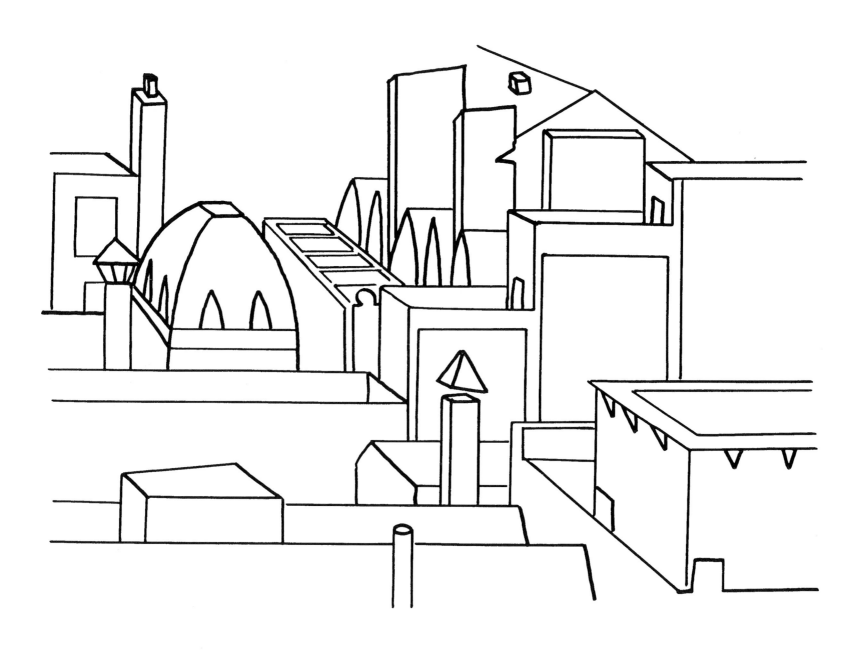

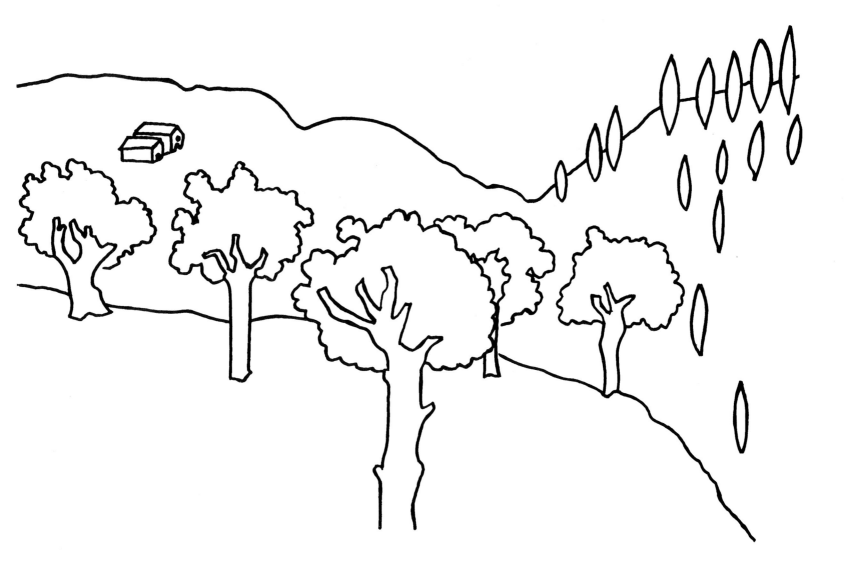

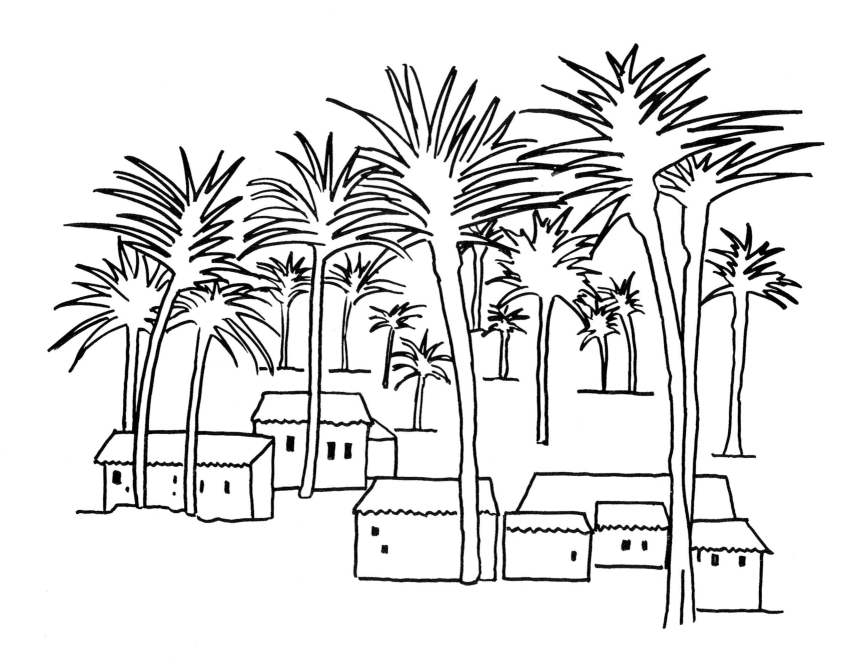

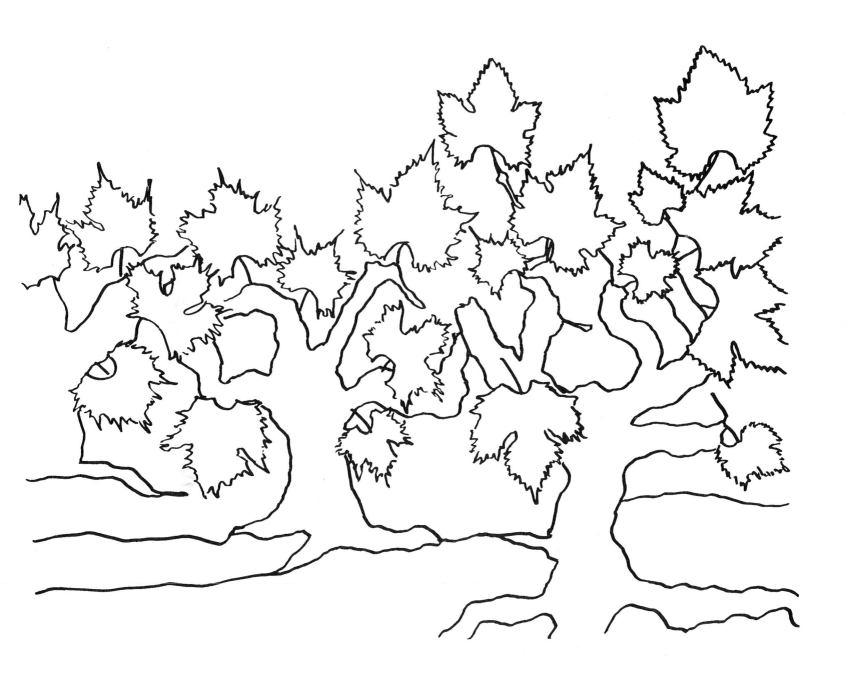

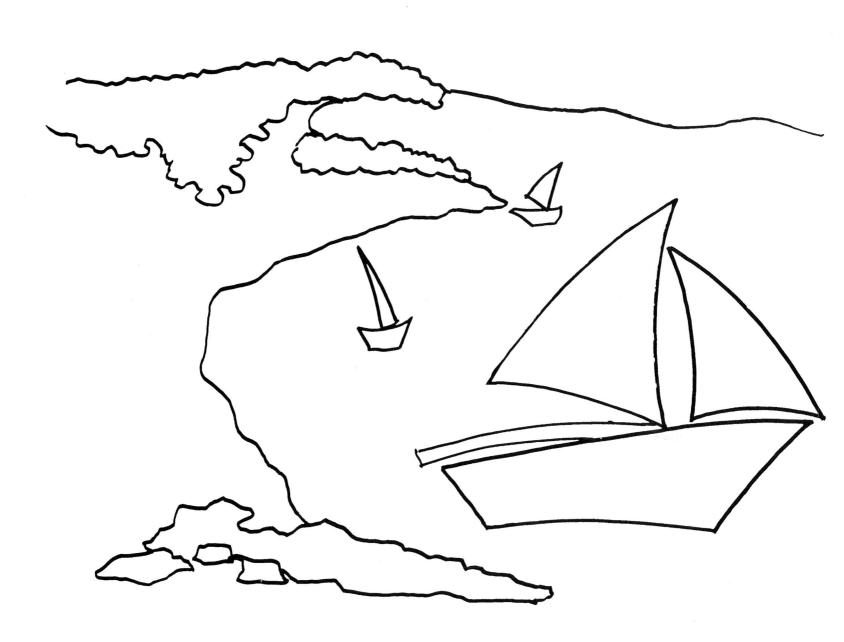

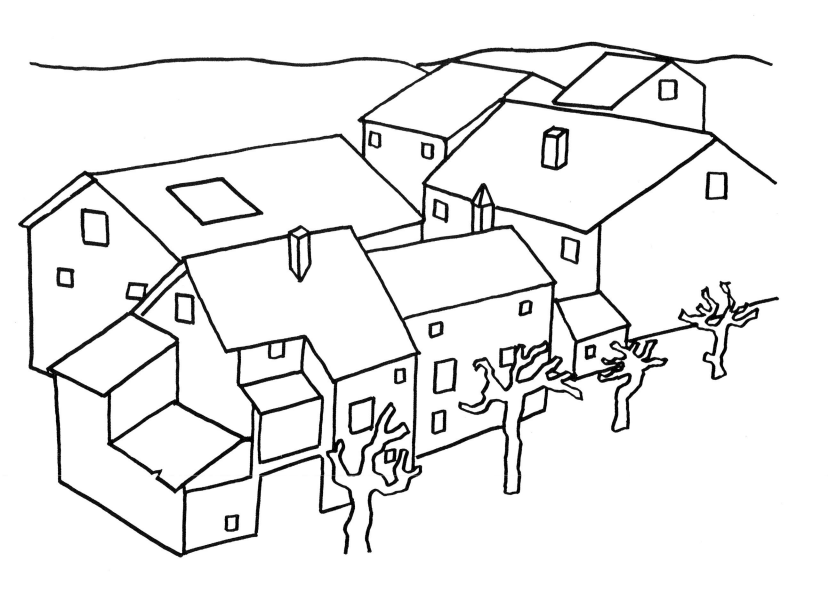

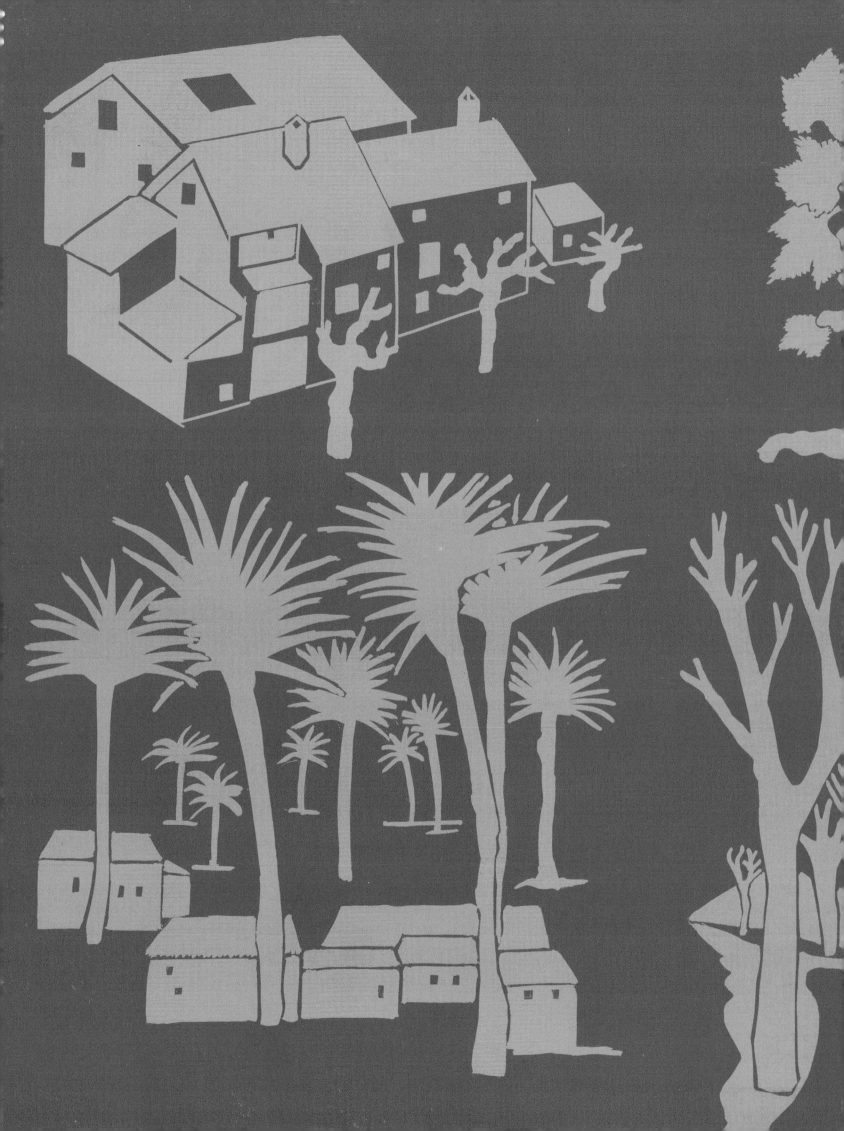